D0190793

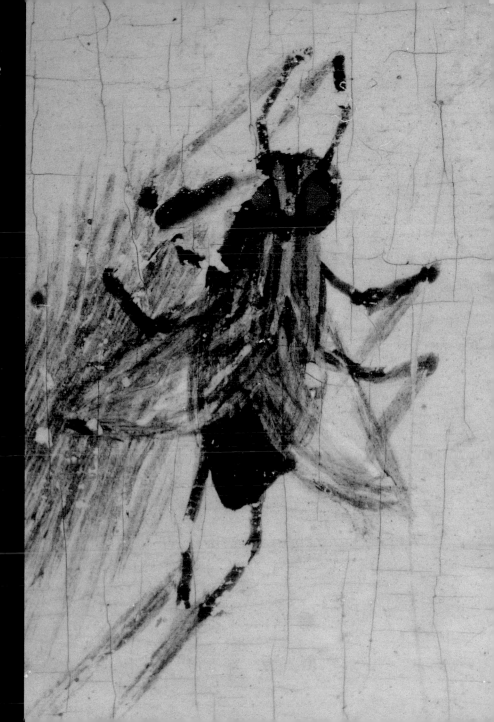

Beyond the naked eye

Details from the National Gallery

Beyond the naked eye

Details from the National Gallery

Jill Dunkerton and Rachel Billinge

National Gallery Company, London
Distributed by Yale University Press

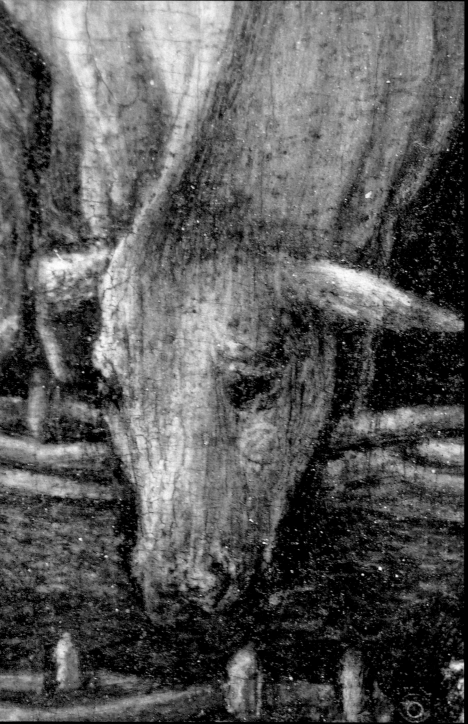

First published in Great Britain in 2005 by
National Gallery Company Limited
St Vincent House, 30 Orange Street,
London WC2H 7HH
www.nationalgallery.co.uk

ISBN 1857O 9381 X
525333

British Library
Cataloguing-in-Publication Data
A catalogue record is available from
the British Library
Library of Congress Catalog Card
Number 2005928886

Publisher Kate Bell
Project Editor Tom Windross
Design Boag Associates
Production Jane Hyne, Penny Le Tissier

Colour reproduction by DL Repro Limited
Printed and bound in Hong Kong by
Printing Express

All measurements give height before width

Front cover: detail of painting Qiii
Page 1: detail of painting Sii
Page 2: detail of painting M T
Back cover: detail of painting T

< R

Contents

Beyond the naked eye

There is disagreement as to where and when the magnifying properties of convex pieces of glass first came to be exploited. Early lenses (their name is taken from the Latin word for lentil, whose shape they resemble) were made from ground and polished rock crystal and, by about AD 1000, they were being used as 'reading stones' by monks and scholars. These had to be placed directly on to the page being read, however, and so were of no use to scribes and illuminators of manuscripts. By the thirteenth century Venetian glass-makers were able to produce convex lenses for magnifying glasses that could be held between eye and object, and were therefore useful as an aid to reading, writing and painting. By 1300 lenses were being mounted in frames to form spectacles (these were perched on the bridge of the nose, page 42, as the side pieces that hook over the ears were not invented until the eighteenth century).

The invention of spectacles to correct the long-sightedness that is an inevitable consequence of age must have extended the careers of many craftsmen. Moreover, it is difficult to believe that painters did not use some form of magnification when executing details as minute as the scene of a figure visiting the sick (perhaps one of the miracles of Saint Peter) depicted on the tabernacle shutters above the altar in *The Exhumation of Saint Hubert* by Rogier van der Weyden and his workshop (page 7).

Microscopes, in which lenses are arranged in sequence to obtain greater magnification, were invented in Holland at the end of the sixteenth century. Technological improvements eventually led to the development of many types of microscope, including stereobinocular operating microscopes, which were first used by surgeons in the early twentieth century. These have two eyepieces, allowing the viewer to see in three dimensions, which is crucial not only for surgeons, but also for conservators in the examination and treatment of works of art.

Cameras can be attached to microscopes to record the images produced. They may include video and digital cameras, but for many years the Conservation Department at the National Gallery has been taking photographs (usually called photomacrographs) of paintings through a microscope using 35mm colour film; the illustrations for this book have been chosen from the archive that has accumulated. While

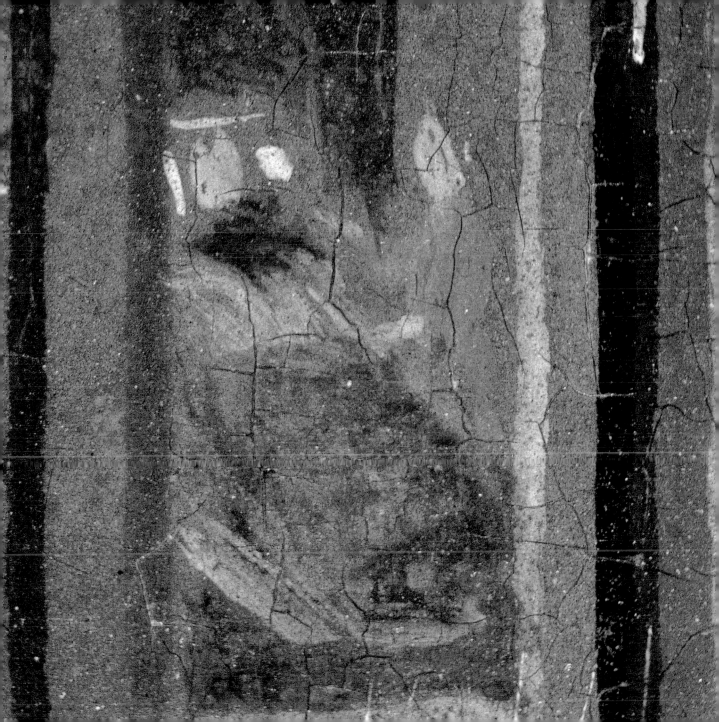

It is possible to enlarge details from images recorded on traditional film or by digital means, a photograph taken through a microscope is already enlarged, even on a strip of 35mm film (twice actual size, in the case of the images here, although much higher magnification is possible). Therefore, this kind of image will withstand enlargement to the size in this book without loss of resolution, while also retaining the richness and depth of colour characteristic of photography on film. In addition, the fact that only a small area of a painting at a time can be viewed through the microscope means that our attention is drawn to details that the roving eye might easily overlook. In an early Netherlandish painting full of visual interest such as *The Magdalen Reading*, a fragment from an altarpiece by Van der Weyden, it takes the magnifying powers of the microscope to observe that the tiny figure of a woman seen though the window is complete in every detail, and that her broken up reflection appears in the rippling water below (page 9, left and right).

Photomacrographs are taken of paintings of all periods; images of a tooled gold halo on a fourteenth-century panel or the swirl of impasto on a Van Gogh, for instance, can be both informative and have abstract decorative appeal. In making a selection, however, we found that the most fascinating images are usually those, such as Van der Weyden's woman, where the subjects remain recognisable in spite of their small size and high magnification

Accurate observation of detail was important to the developments that took place in early-fifteenth-century Netherlandish painting, so photomacrographs from works of this period are obvious candidates for inclusion here. Subsequently, painters in Italy, Germany and Spain developed similar interests, sometimes in direct imitation of Netherlandish examples. In the sixteenth century painting techniques began to change, especially in Italy, and the adoption of freer, more painterly brushwork resulted in less emphasis being placed on the minute description of details. The latest painter to be included in this book is the northern artist Pieter Bruegel the Elder; the images from his *Adoration of the Kings*, painted in 1564, show the astonishing speed and confidence with which he handled his paint.

Both conservator and art historian can learn much from the examination of paintings with the stereobinocular microscope. This information supplements that gained by X-ray and infrared methods of examination, and from the scientific analysis of paint samples. The way in which the painter built up the image may become apparent, so that in a thinly painted picture, such as Zoppo's *The Dead Christ Supported by Saints*, the white gesso ground gleams through where the paint is thinnest (page 32, bottom). The outlines of Christ's lips were drawn first on the gesso, and then only thinly covered with paint. In this instance the drawing was surely intended to be partially visible, as there are no

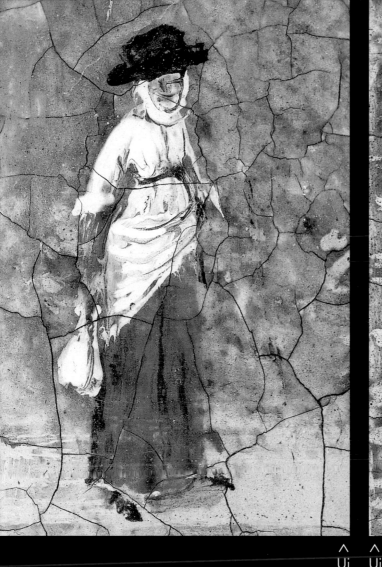

painted lines to reinforce them, but in some of the other illustrations in this book underdrawn lines that do not necessarily coincide with the final painting can now be seen, as a result of the increasing transparency of the paint layers over time (pages 33 and 36, right).

With magnification you can differentiate between different methods of applying gold leaf (pages 50 and 51), and sometimes individual pigment particles can be distinguished, especially those based on minerals such as ultramarine, azurite and malachite, which if they are ground too fine will lose their intensity of colour (page 11). The sequences of the paint layers with which artists built up colours or particular effects are clarified and, in the case of works executed in an oil medium, it is also possible to determine whether the lower layers were allowed to dry before more paint was applied (see page 55, bottom), or whether layers were worked into one another while still soft (page 56, top and bottom). The wide variety of ways oil paint can be manipulated also becomes apparent (see pages 56–59). Another characteristic of oil paint is its tendency to form lead soaps when used with lead-based pigments such as lead white and lead-tin yellow; these give the paint a distinctive granular texture, which you can see under sufficiently high magnification (page 41, bottom).

In paint layers applied in egg tempera, the principal medium used in Italy until the mid-to late-fifteenth century, look very different in photomacrographs. The egg medium contains a high proportion of water, which evaporates quickly, and so the paint lacks the body of oil colours. If the paint is very dilute this may result in a soft, slightly blurred effect, almost like that of watercolour (pages 4, 19 and 26). In addition, the colours cannot be blended while wet. Therefore painters had to apply them with individual hatched and stippled strokes. They appear blended when viewed at a distance but, when the paint surface is magnified, every stroke can be distinguished (page 34, top). Although egg tempera is not as accommodating a medium as oil, it can be applied using small sponges for marbling, or spattered onto the surface by flicking a stiff brush loaded with paint to suggest speckled marble or tiny pebbles. Mantegna was a master of this technique: under magnification you can see how the flicking has aerated the paint, causing it to foam and resulting in tiny burst air bubbles in the spatters (page 13).

Tempera and oil paintings crack in different ways. With time, any painting as old as those included in this book will have developed a network of cracks, and so they feature in all of the images. The larger heavier ones have usually formed in the gesso or chalk ground (pages 32, top and 32, right) and their pattern may be determined to some extent by the direction of grain of the panel's wood – indeed, on Bonsignori's panel the ground is so thin that the

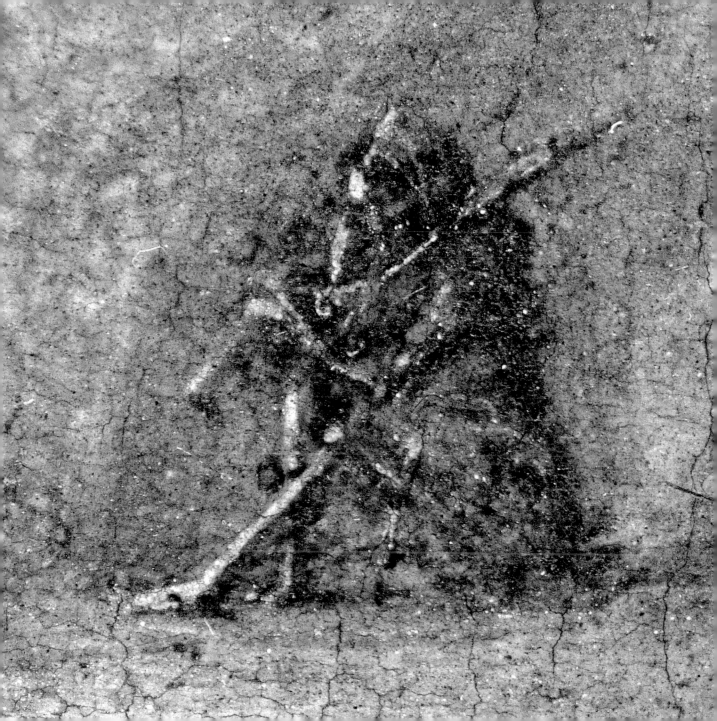

grain is apparent on the surface (page 46, bottom). In the case of paintings on canvas, such as Mantegna's altarpiece (see picture Jii), the only canvas to be included here, the direction of the main cracks is generally more random. Within these are networks of finer cracks. Those on tempera paintings tend to be very finely crazed, so that they are barely visible without magnification (pages 4; 32, top; 44, bottom), whereas in oil paintings they are more pronounced, and can vary in character and extent from colour to colour. Areas of dark green, for instance, are usually more heavily cracked than other colours (page 47). In addition, cracks in oil paintings often stop short of intersecting with one another.

All these are features of old paintings that make the detection of modern forgeries relatively straightforward with the aid of a microscope. They are also important to modern restorers in identifying areas of paint that may have been added in an earlier restoration.

The composition of nineteenth- and twentieth-century restorers' colours is very different from older paints. New pigments have been introduced, and machine-ground paints, as opposed to the hand-ground colours of the Renaissance, have smaller, more regular particles. Unless they are very old, restorations and repainted areas will not have cracked and can often cover cracks in the original paint: for example, the two small retouchings (invisible in normal viewing conditions) on the lips of

the *Portrait of a Woman* from the Van der Weyden workshop (page 14 – one is in the dark red between upper and lower lips, almost at the right edge, the other on the lower lip, again towards the right). Areas of restoration can be identified on several details in this book, notably in the family group from the landscape in *A Man Reading (Saint Ivo?)*, where they are slightly smudged and lighter in colour (page 27, top), while the mordant gilt crozier on the panel by Fra Angelico has evidently been restored using powdered 'shell gold' (page 50). Others have small losses, usually chips and flakes from the edges of cracks which have not been retouched since they are not visible or disturbing except under magnification. Surface accretions such as residues of old varnishes not removed in past cleanings are also evident on many of the paintings.

For the art historian the microscope can help to clarify who actually painted the picture. In the nineteenth century the pioneering Italian art historian, Giovanni Morelli, developed what he considered to be an objective and scientific approach to attribution. This included analysis of the different ways in which different artists represented specific details such as eyes, mouths, ears, fingers and so on. Consciously or otherwise, art historians still follow many of these criteria when considering an attribution. Photomacrographs can usefully be employed in an extreme version of Morellian analysis, especially with exquisitely detailed and small-

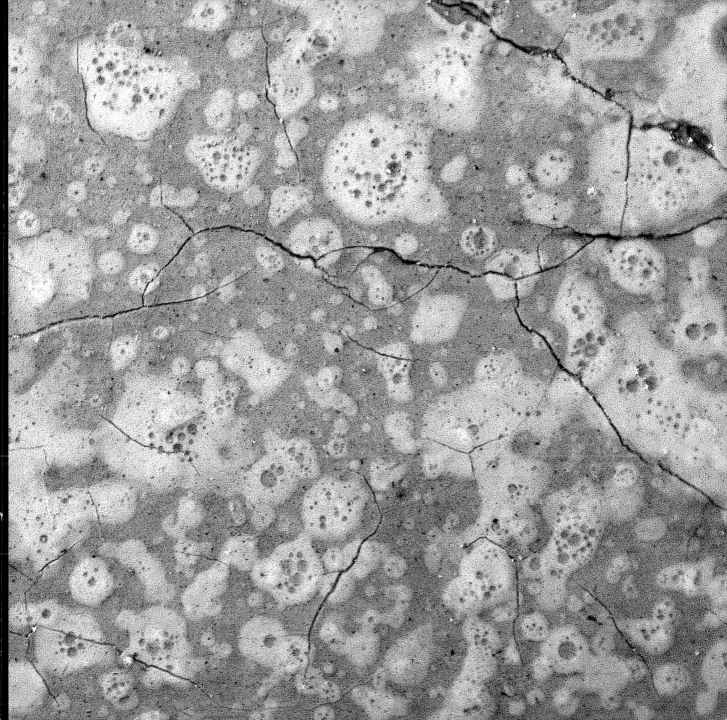

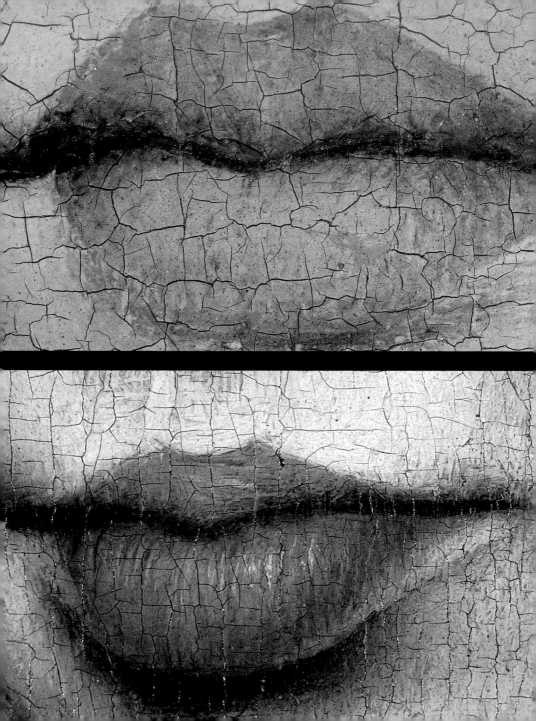

scale pictures such as Raphael's *Madonna of the Pinks* and *The Garvagh Madonna*. These were painted within a few years of one another, and among their many technical similarities are the painting of the soft pink mouths of the children, where the projection of the upper edges is emphasised by touches of almost pure lead white (page 33 and front cover). Conversely, magnification can also expose differences. The National Gallery's *Portrait of a Lady* has sometimes been thought to be the work of Rogier van der Weyden. A comparison, however, with a similar portrait in the National Gallery of Art, Washington, reveals weaknesses in the London painting, especially in the drawing and general design. When the microscope is used to focus on equivalent details from each, the differences become striking (page 14, top and bottom). The execution of the mouth in the London version (top) is competent and perfectly convincing, but without the astonishing powers of observation and skill in execution in the Washington portrait (bottom). Here the impression of volume and structure, combined with an almost obsessive interest in detail such as the fine creases in the lower lip, confirm that this portrait is the one by Van der Weyden himself.

The images that follow, therefore, were recorded for many different reasons. Their publication here enables us to share our experience of looking down a microscope at these superbly crafted paintings. We hope that they will both instruct and delight.

How to use this book

The whole paintings from which details were photographed for this book are reproduced on pages 60–80, each with an identifying reference (for example M or Sii). Each detail is marked with a reference that identifies which painting it comes from, and if you turn to that painting at the back you will find a circle identifying where on the painting the photomacrograph is from. The numbers in the circles are the pages on which the detail can be found.

The photomacrographs here are reproduced at one of three magnifications:

Small rectangular images (for example those on page 18) show an area of paint 11×17 mm, giving a magnification on the page of $8.4\times$.

Larger rectangular images (such as page 1 or page 25) also show an area of paint 17×11 mm, but with an $11.2\times$ magnification.

Images filling a whole page show an 11mm square of paint, with a magnification of $17.3\times$.

Page 14 (below), and page 79 (far right)
Rogier van der Weyden
Portrait of a Lady, about 1460
Oil on panel, 37×27 cm
National Gallery of Art, Washington
Andrew W. Mellon Collection (1937.1.44)

Observing the world

In the early fifteenth century painters began to study and depict the world around them with increasing fidelity, replacing established conventions for the representation of figures, landscape and architecture with images based on direct observation. This was especially the case in the Netherlands, with the emergence of the exceptionally gifted painters Jan van Eyck, Robert Campin and Rogier van der Weyden. Even a painting set in an interior, whether a portrait or a Virgin and Child, might include scenes of life outside as seen through an open window. These scenes, which could show anything from a family dancing to the bagpipes (page 27) to a workman repairing a roof (page 25), are clearly unrelated to the principal subject of the painting.

Netherlandish paintings were exported all over Europe and Italian patrons and painters were evidently as delighted and fascinated by these detailed renditions of fifteenth-century life as we are today. Some Italian artists, for example Antonello da Messina (page 17) and Antonio de Solario (page 24 and back cover), set out to imitate these minute landscapes. When viewed up close, however, Antonello's handling of his oil colours, with their stiffer, less tractable texture, appears very different to that of his Netherlandish models.

Mantegna must have also seen examples of Netherlandish art, but his enchanting rabbits (page 19) additionally owe much to the Northern-Italian tradition of the careful observation of birds and animals, as exemplified by the drawings of Pisanello. The fluid medium of egg tempera allowed him to hatch the rabbit's fur with the point of his brush, just as in a drawing.

The accurate representation of botanical details of fruits and flowers, whether by Van Eyck (page 23) or Raphael (page 22, top) means that they are immediately identifiable. Even when a plant, bird or animal is more stylised, as is Lochner's eagle (page 21), or painted so small or so rapidly that they consist of no more than a few strokes of the brush, the marks can be recognised as sheep (page 18, top), or as birds perched on a windowsill (page 20, top). When the painting is viewed with the naked eye they are identified as such by their poses and characteristic behaviour; only with magnification do we appreciate the directness and simplicity of their execution.

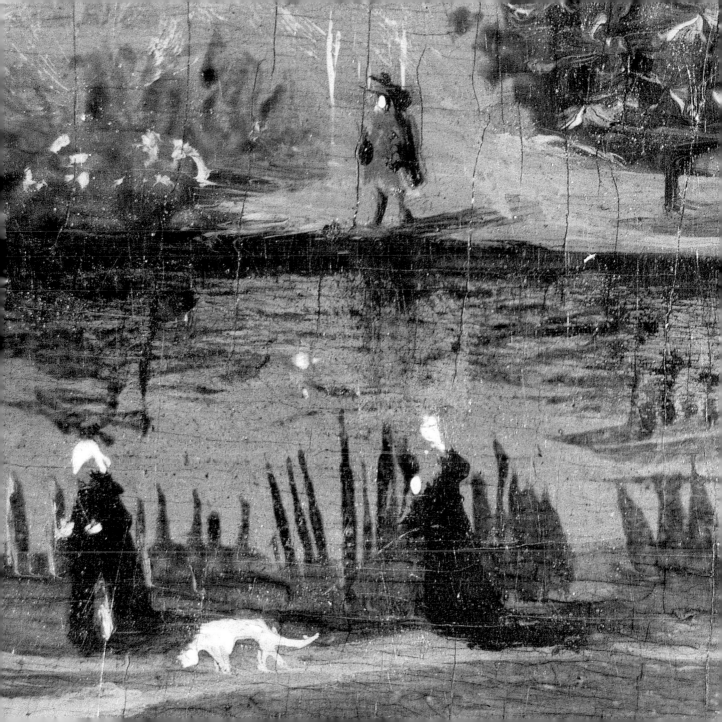

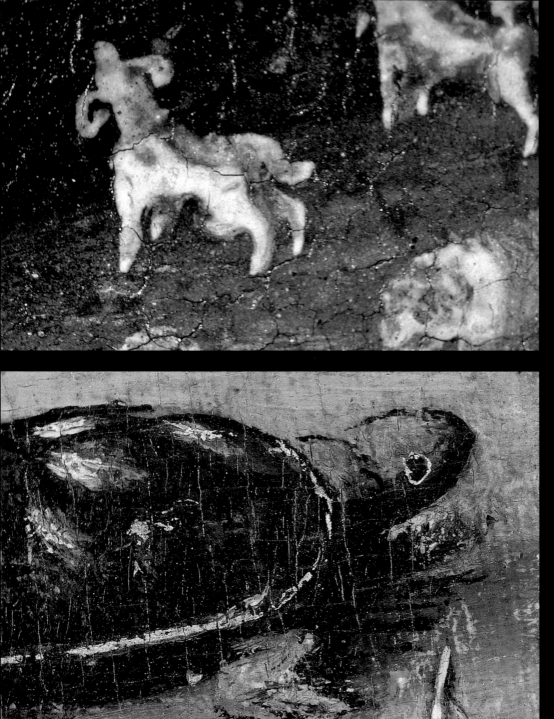

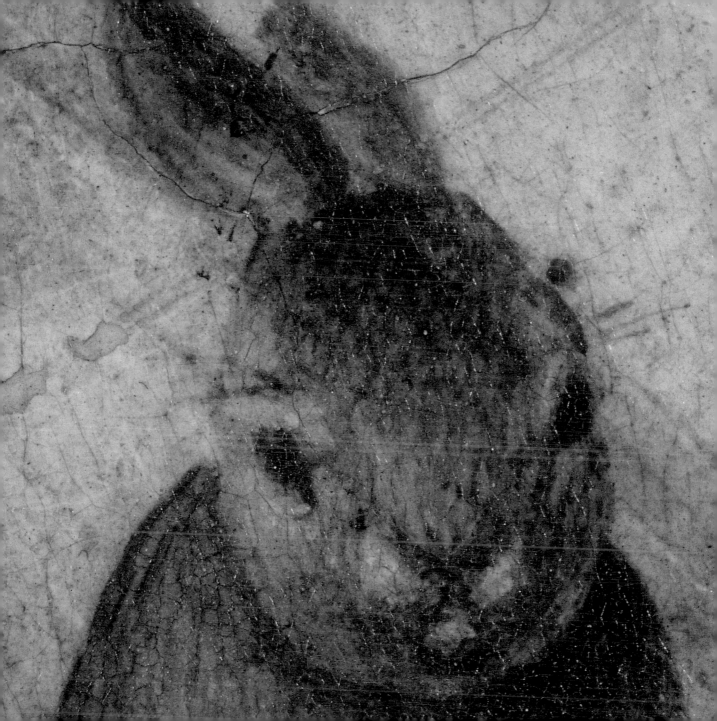

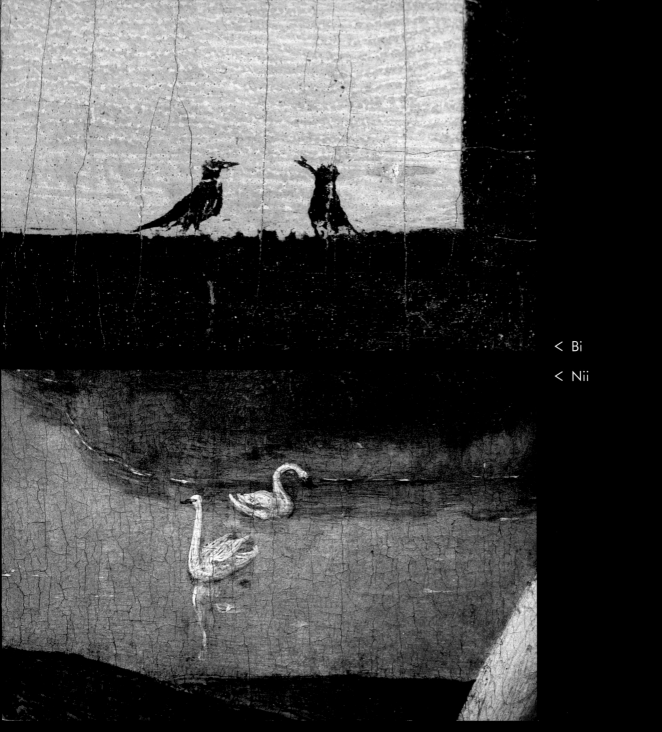

< Bi

< Nii

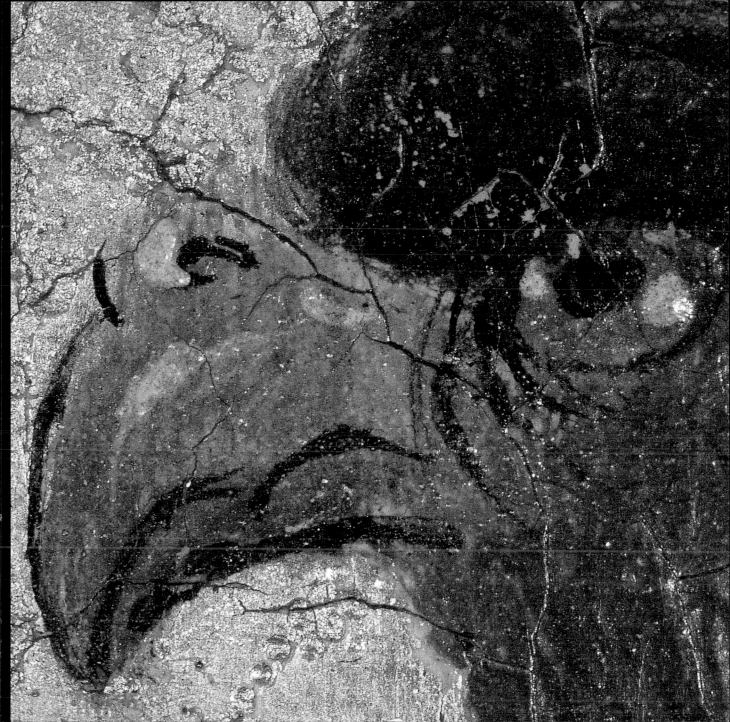

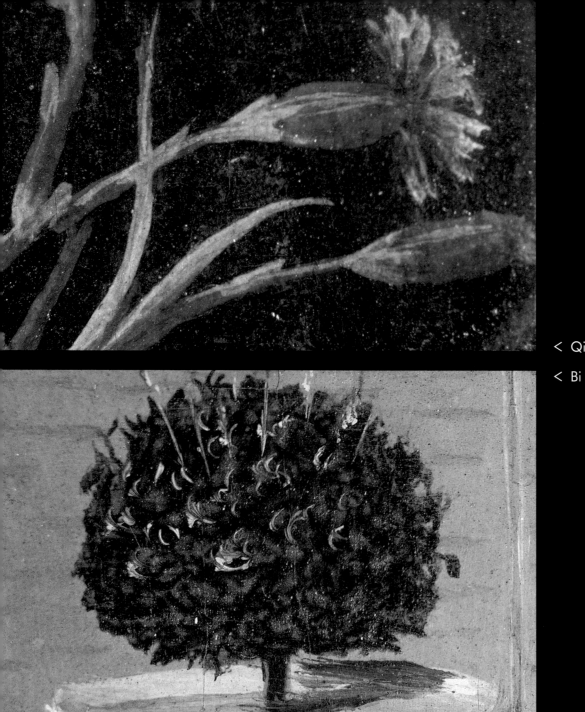

< Qii

< Bi

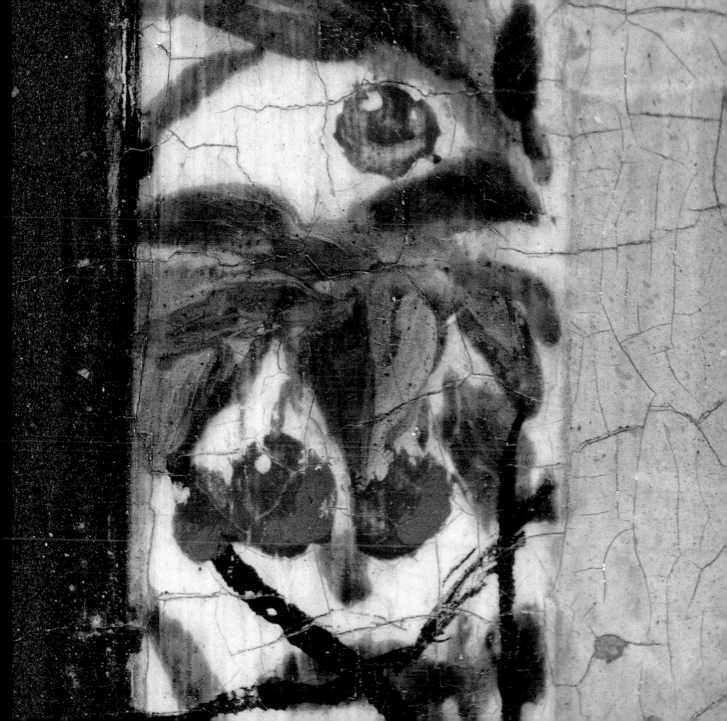

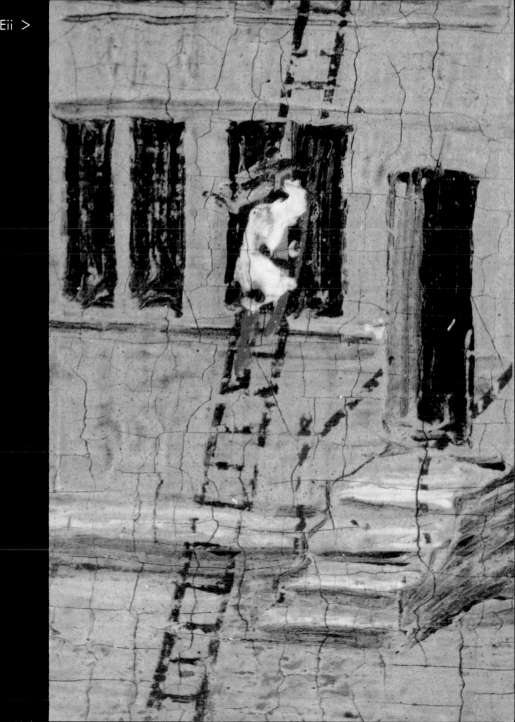

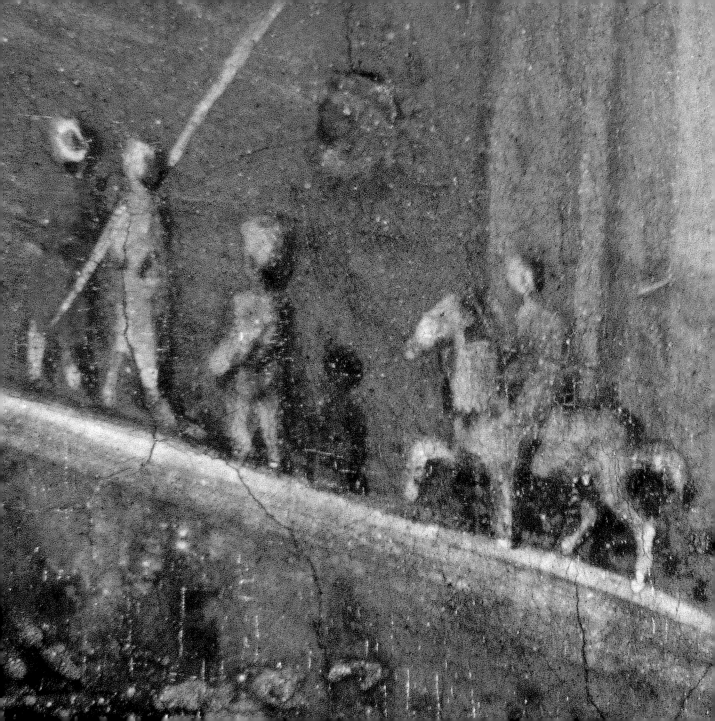

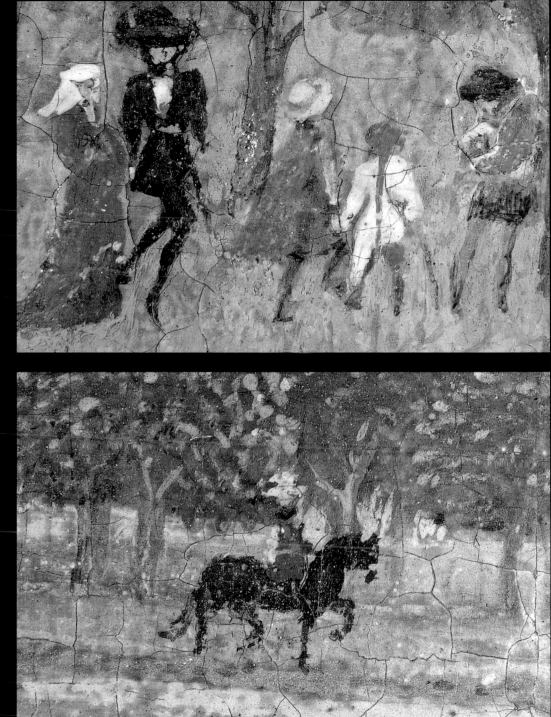

Uiii >

Uiii >

Portraying mankind

When we see paintings of fellow human beings, we are immediately attracted to those features that we instinctively monitor on a human face which enable us to register the character and mood of the subject. Even when taken as an isolated detail, the eye of the acolyte raising the body of the Saint Hubert (page 29) suggests concern and wonderment. Tenderness and modesty are expressed by the lowered eyelids of the Virgin painted by Morales with a blurred sfumato technique (page 30) that contrasts with the crisp precision of Campin's painting of the eye of his *Portrait of a Woman* (page 31, top). Her averted gaze suggests reserve, shyness even, while the six-year-old Johann Freidrich the Magnanimous glances slightly uncertainly to the right (page 31, bottom). In both portraits the painting of the catchlights, with touches of solid lead white, indicate the convexity and wetness of the eyes and also the light sources – evidently a window in Cranach's portrait, since the glazing bars are reflected on the surface of the child's eye.

The plump pink lips of the Christ Child in Raphael's panels (page 33 and front cover) induce a different response in the viewer from the gaping mouths of the sleeping apostle in Mantegna's *Agony in the Garden* (page 32, top) or Zoppo's crucified Christ, whose death and suffering is evoked by the absence of any red pigment from the flesh tints (page 32, bottom). The distinct hatched brushstrokes typical of egg tempera are clearly visible on the paintings by Mantegna and Zoppo, whereas Raphael's use of oil has allowed him to blend tones into one another while the paint is still soft.

Although neither Mantegna nor Zoppo used the green earth underpainting for flesh that is apparent on many Italian tempera paintings, it features in the tiny praying hands of an angel in Fra Angelico's predella panel (page 36, left). The hands are too small to show the details of knuckle creases and finger and toe nails that appear on the panels by Van der Weyden (page 36 right) and Pacher (page 37). Provided the painter had a suitably fine-pointed brush, both tempera and oil could be used to paint lines to depict hair, whether in twisting ringlets or fluffed up in random curls (pages 34, top, and 35, left). Alternatively, hair might be rendered as more sculptural clumped locks (page 35, right) or, for the stubble on an old man's chin, dabbed on in minute spots of lead white (page 34, bottom).

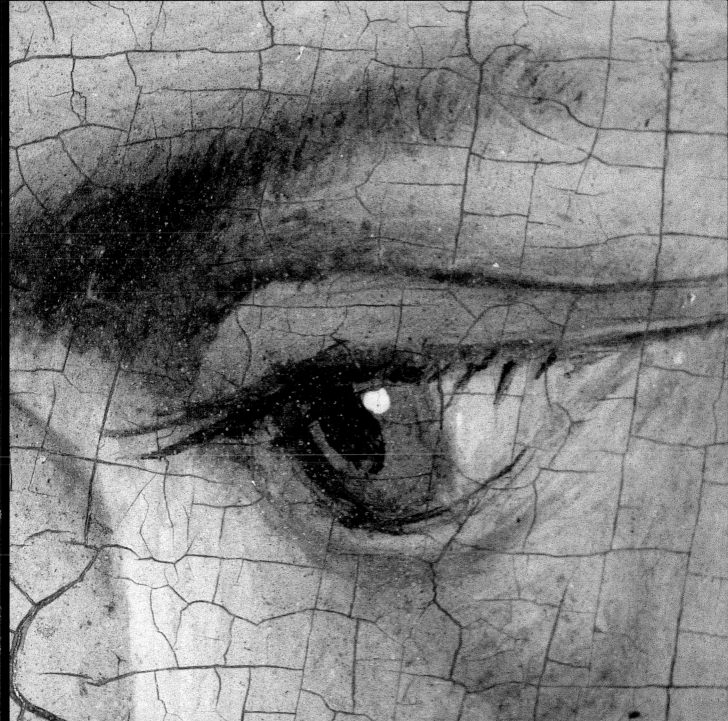

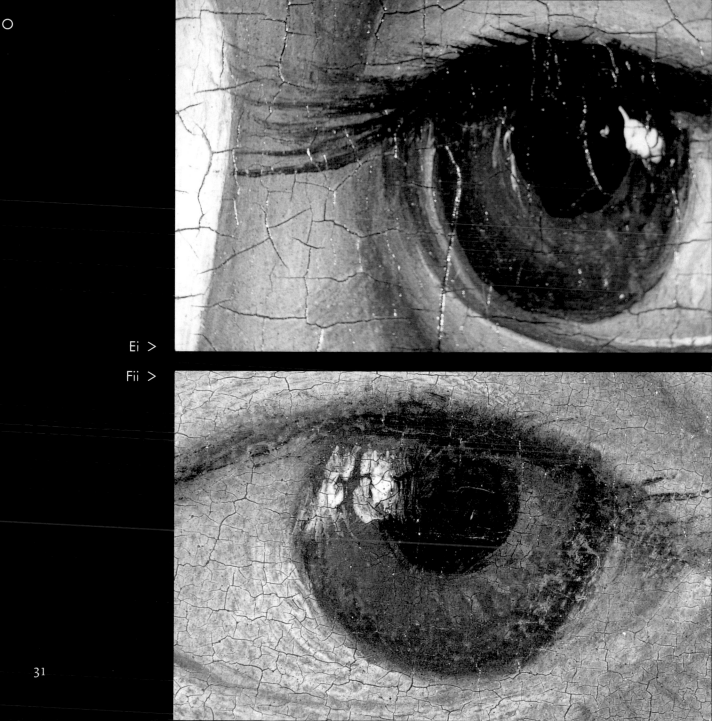

Ei >

Fii >

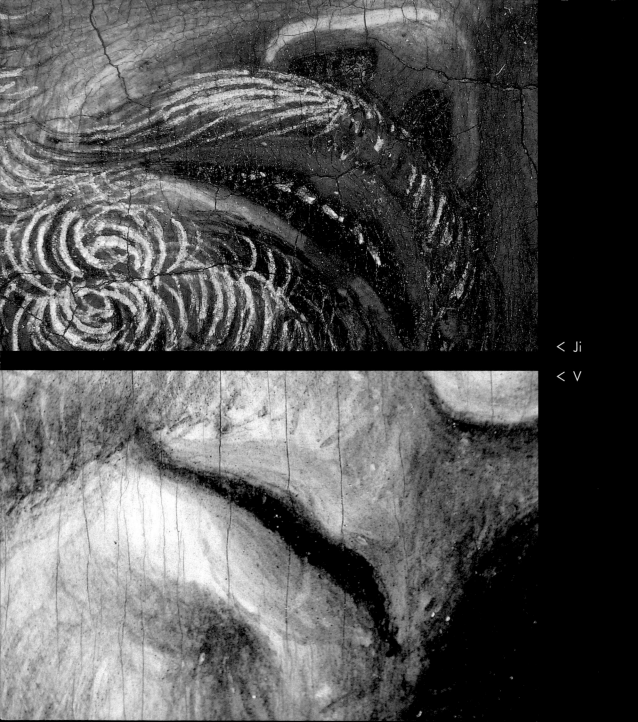

< Ji

< V

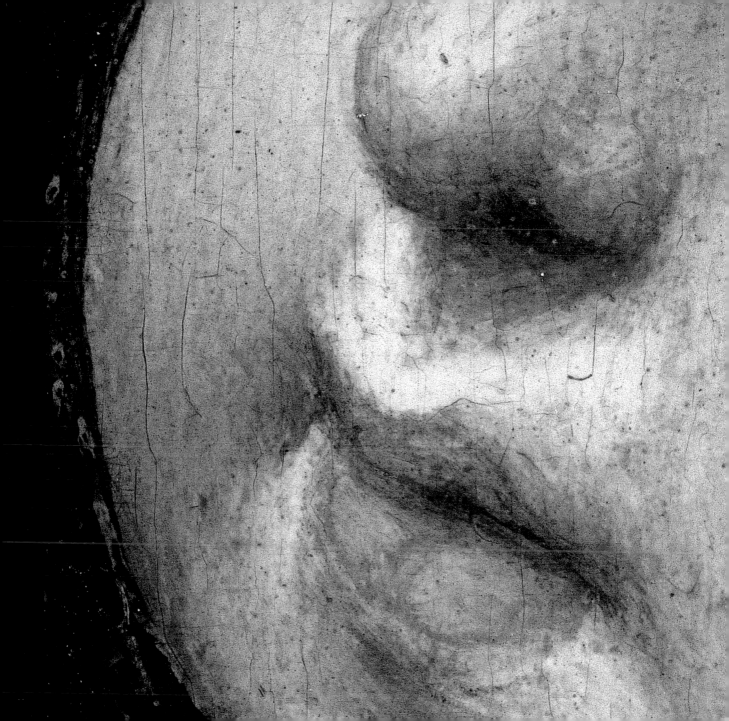

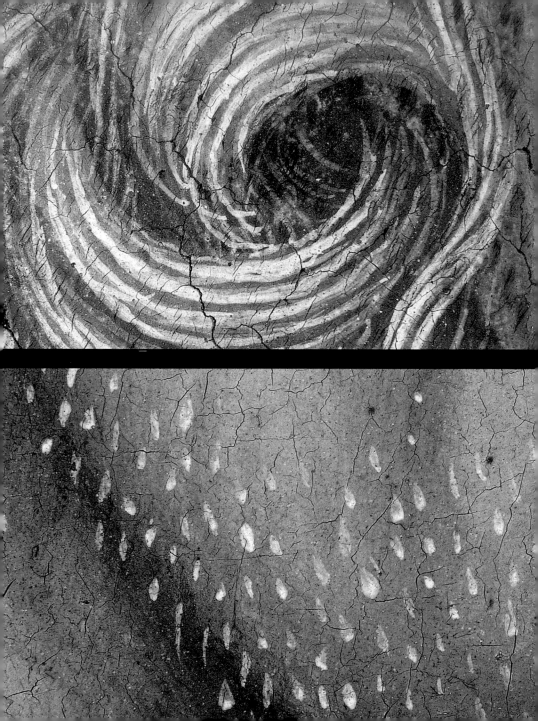

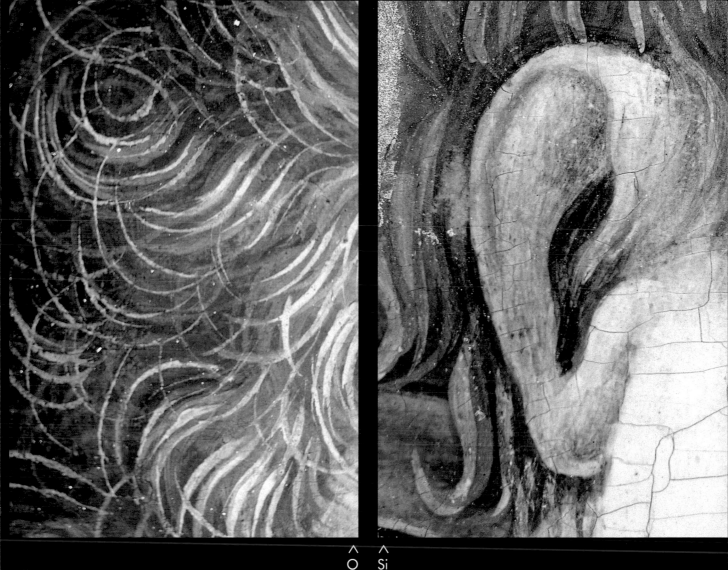

O Si

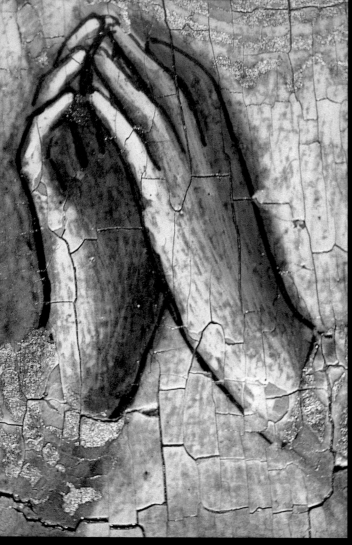

^ ^
Aii Ui

^ ^
Aii Ui

P >

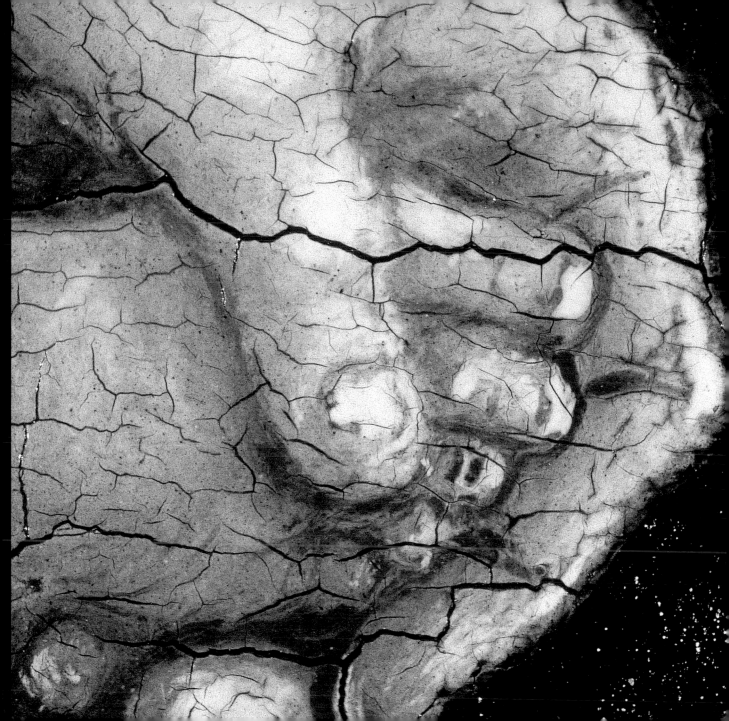

of people and nature also inspired painters to attempt accurate descriptions of objects. On the flat surfaces of their panels and canvases artists produced astonishing renditions of different textures and surfaces. They might be hard and reflective as in polished precious stones, both facetted and cabochon, set in gold mounts, executed either with real gold leaf (page 41, top) or in yellow paint. In Cranach's jewellery the claws of the mount are painted with raised blobs of lead-tin yellow pigment (page 41, bottom).

Bruegel's dabs and dashes of lead white denoting the nacreous reflections on the nautilus shell incorporated into Balthazar's gift to the infant Christ (page 39) contrast with Memling's systematic depiction of pearls (page 40). Over a mid-grey base Memling painted a principal highlight of lead white, slightly off centre to indicate the direction of light, a darker grey crescent on the shadowed side and then a secondary reflected highlight towards the outer edge. This Netherlandish technique was copied all over Europe.

The glassy surface of Van Eyck's amber prayer beads (page 43) is suggested by the white and yellow highlights, and their translucency by the light transmitted through them (which produces both cast shadows and points of light on the wall). The curving white highlights on the scenes on the mirror's roundels in the same painting (page 42, bottom) show that they were protected by domes of polished rock crystal. When seen under magnification, the apparent rapidity of Van Eyck's touch may be surprising, but it is as nothing when compared with the boldness and economy with which Bruegel depicted the metal and glass of a pair of spectacles (page 42, top).

Magnification also exposes the clever way in which Antonello gives the illusion of precision in his painting of lines of script (page 45, bottom), although, unlike Van Eyck (page 44, top) and Mantegna (page 44, bottom) in their signatures, neither he, nor the more precise Van der Weyden (page 45, top), could have hoped to paint actual letters, since the books are so very small.

Painters also made much of contrasting textures, for example a metal pin in a soft linen headdress (page 46, top), or a gold fastening stitched to a tunic (page 46, bottom). Both are described with a precision very different from Cranach's flourishes for the feathers of a plumed hat (page 47).

38

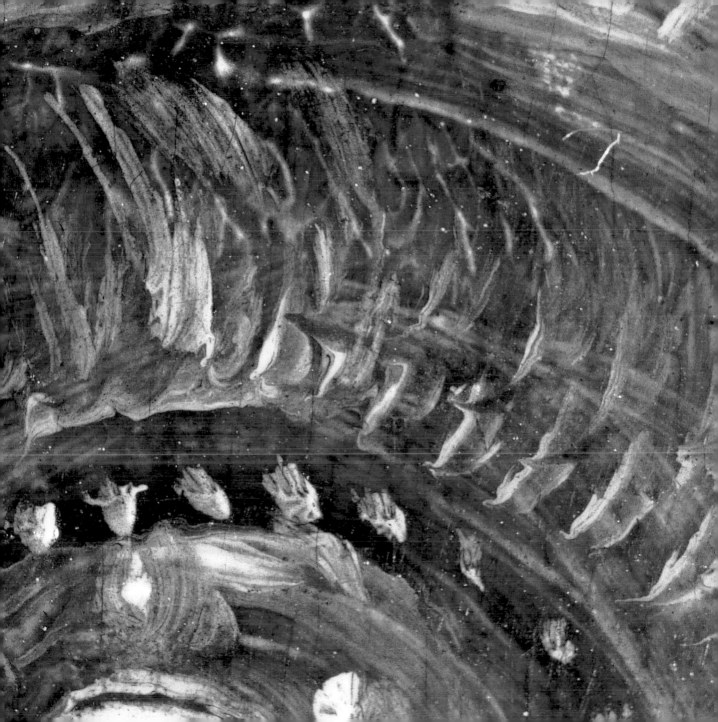

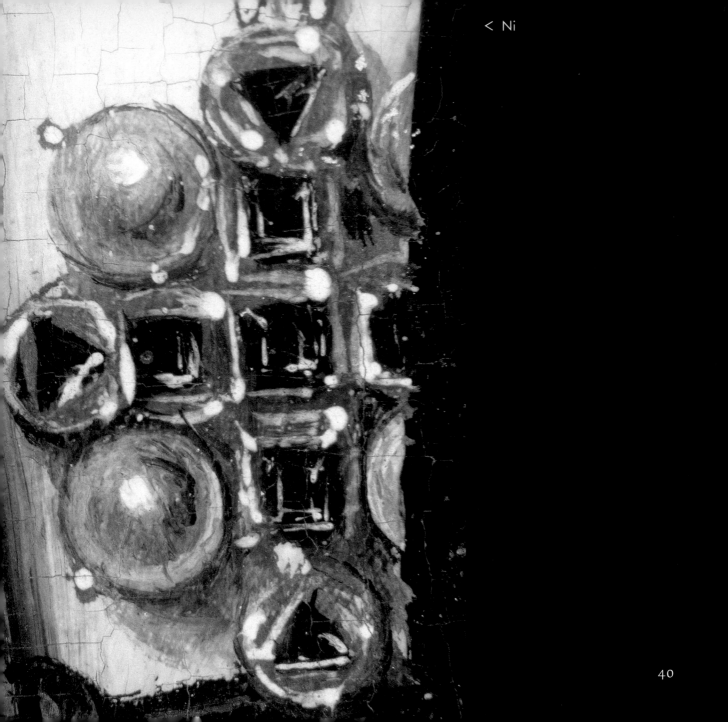

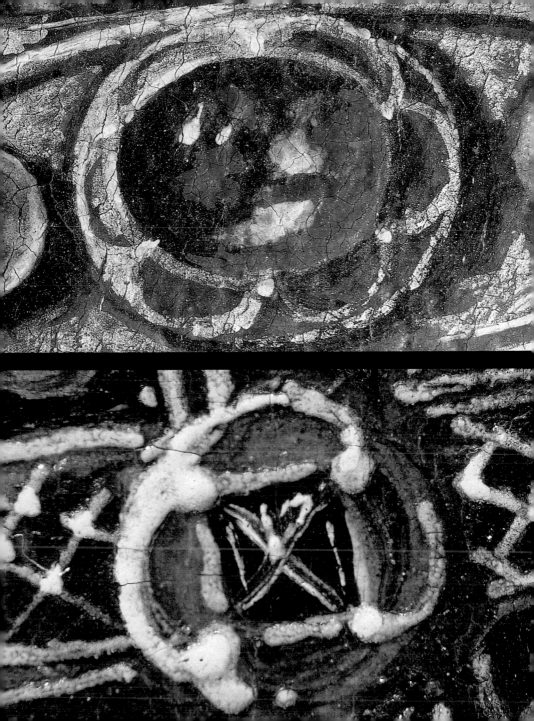

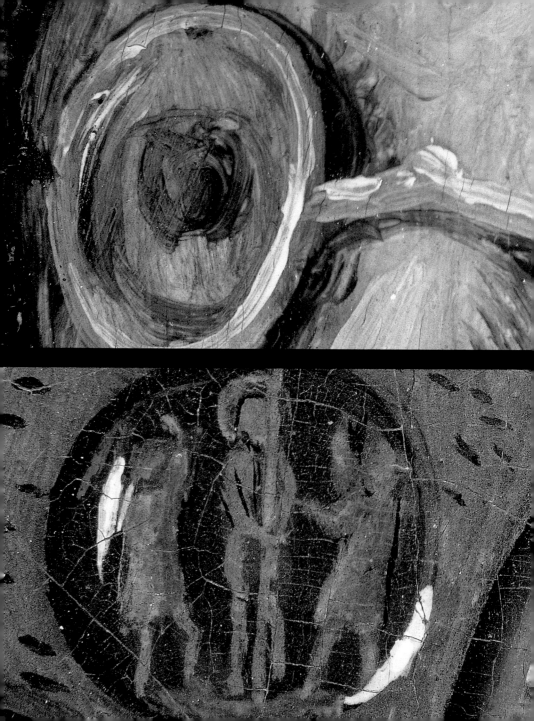

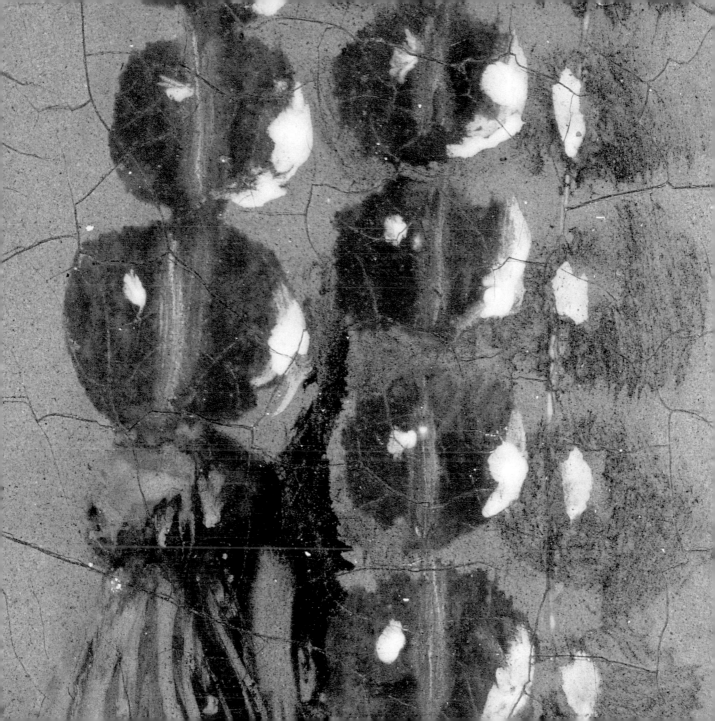

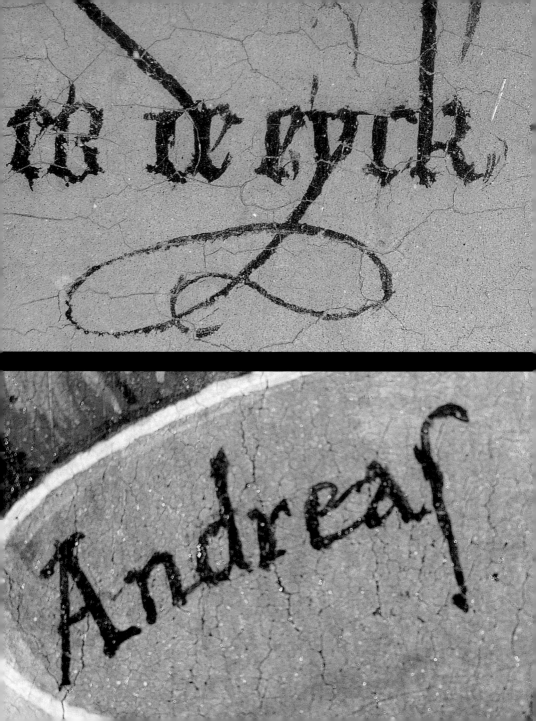

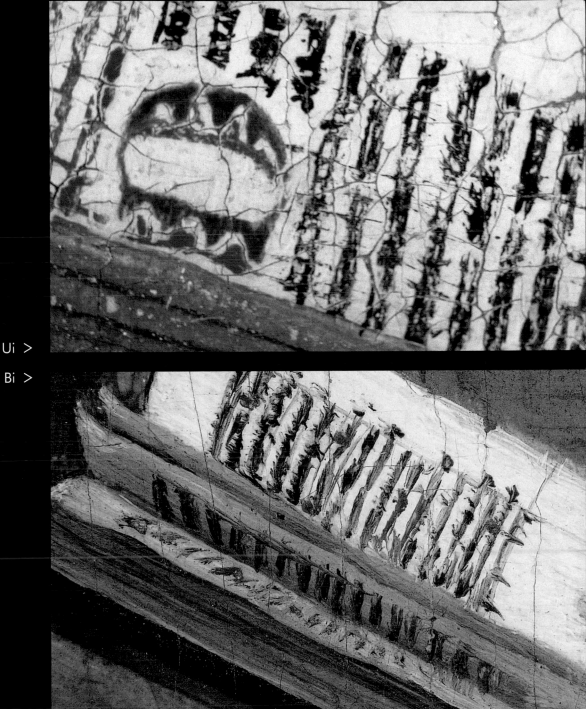

Ui >

Bi >

5

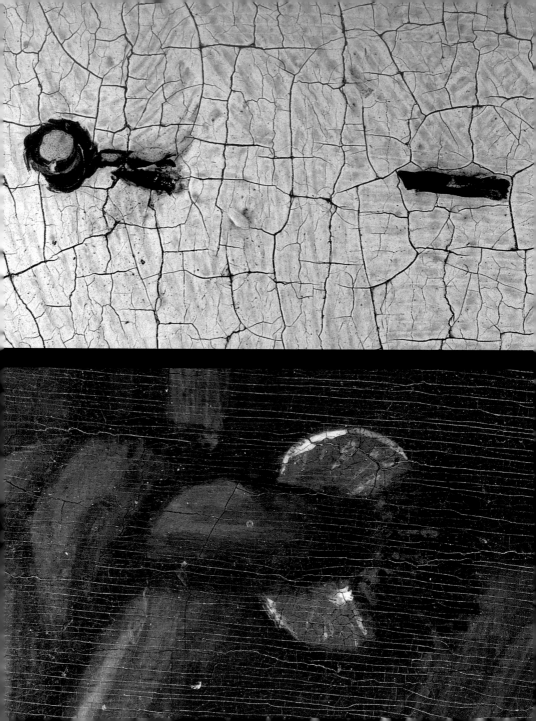

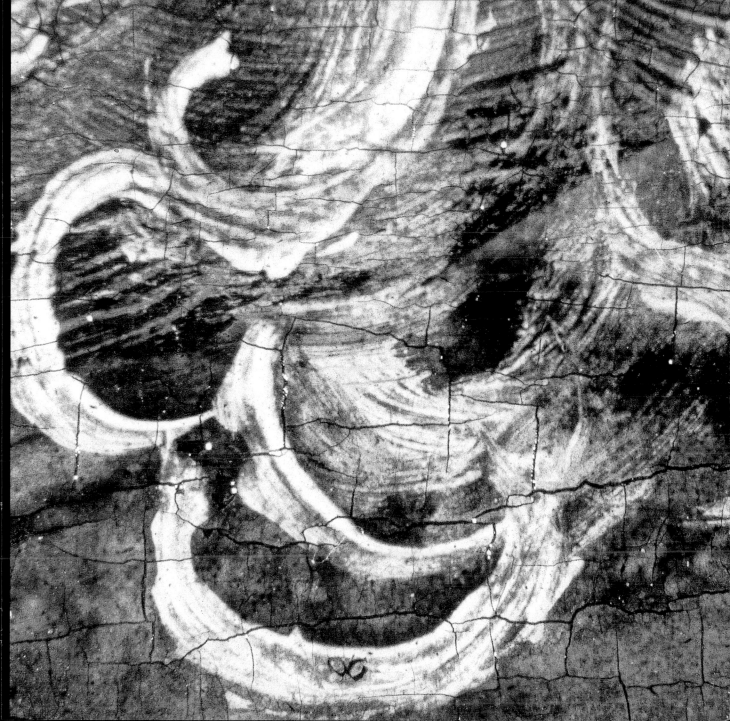

Manipulating materials

When making images Renaissance painters were ingenious in their exploitation of their materials. To represent golden objects gold leaf could be used, often in the form of mordant gilding, in which the shape or pattern to be gilded was painted with an adhesive substance, the mordant. Gold leaf was then laid over it, adhering to the sticky mordant but not to the dry surface of the surrounding paint (pages 50 and 53). Alternatively, gold leaf could be powdered and mixed with a binder to make a gold paint, usually called 'shell gold' because it was traditionally kept in mussel shells. Under magnification, decoration with 'shell gold' (page 51) can usually be distinguished from mordant gilding.

In the Netherlands in the early fifteenth century painters began to create the illusion of metallic objects with paint alone, the lustre and reflective properties of gold indicated by highlights of lead-tin yellow (page 52, top and bottom). This pigment has considerable bulk when applied in oil; if details such as the gold threads in a cloth-of-gold fabric are viewed in raking light, the relief becomes strikingly apparent (page 55, bottom).

Raking light reveals the texture of oil paint and the direction of brushstrokes. A stroke made with a paint containing dense lead-based pigments may form ridges of impasto (pages 49 and 54). Brushes can be used to manipulate the colours while they are still soft so that they bleed into one another or displace the paint of previous strokes – the technique of wet-in-wet painting (page 56, top and bottom). Soft oil paint can also be worked with implements other than the brush. Campin used a pointed stick (perhaps the other end of a brush) to indent the fabric edges of a folded linen headdress (page 55, top), while Van Eyck actually scraped the wet paint away to indicate the bristles of a dusting brush (page 57, top). Antonello used exactly the same technique for the fringe of his sitter's hair (page 57, bottom).

To ensure that final glazes were suitably thin and even, painters often blotted off the surplus paint, either by dabbing with rags, which leaves the imprint of the woven fabric (page 58), or they could use their fingers, thumbs and palms. This is almost an instinctive action when using oil paint, and such prints are common on paintings. They allow us quite literally to see the hand of a great artist such as Van Eyck (page 59, top) or Raphael (page 59, bottom).

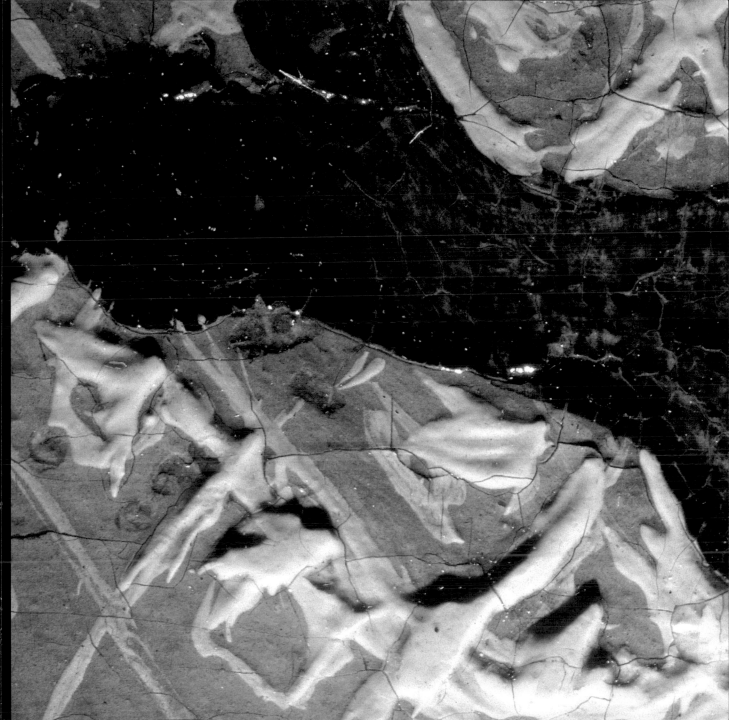

< Ai H >

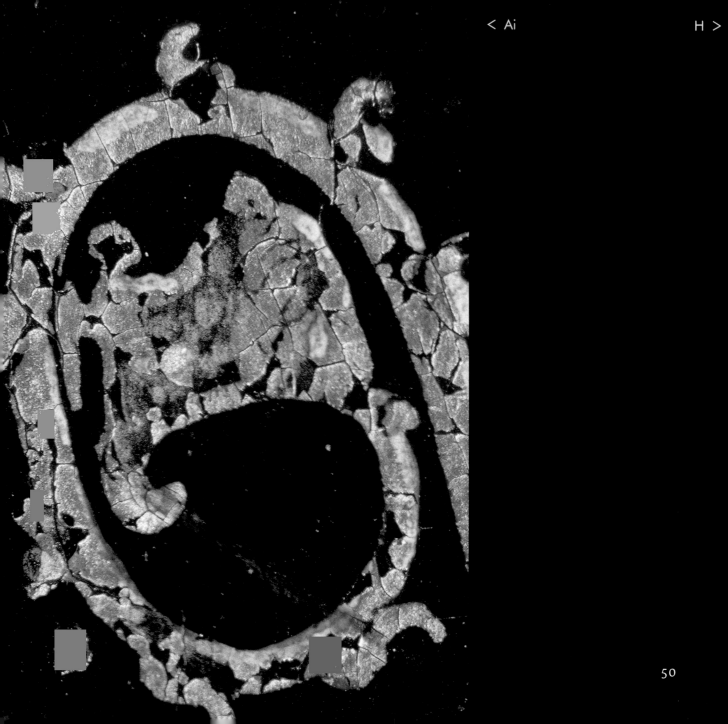

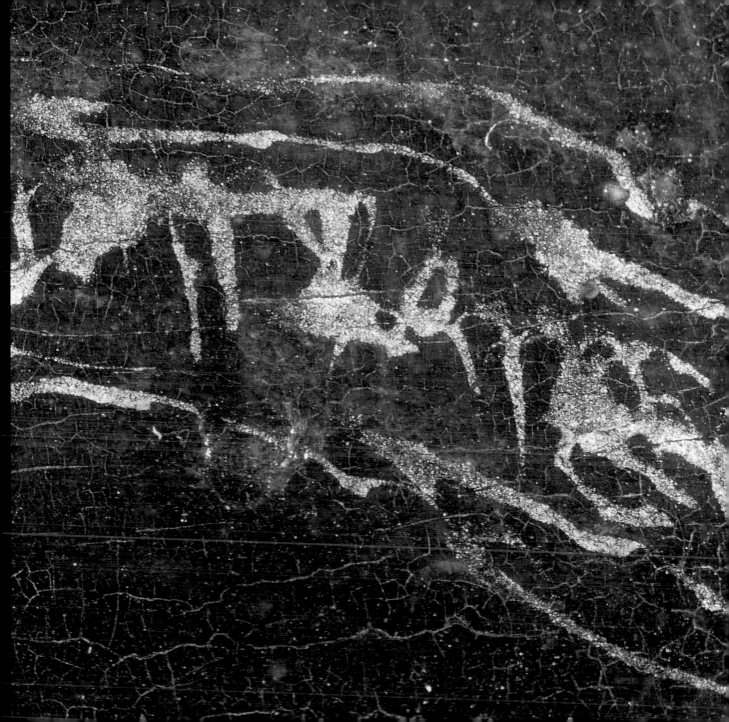

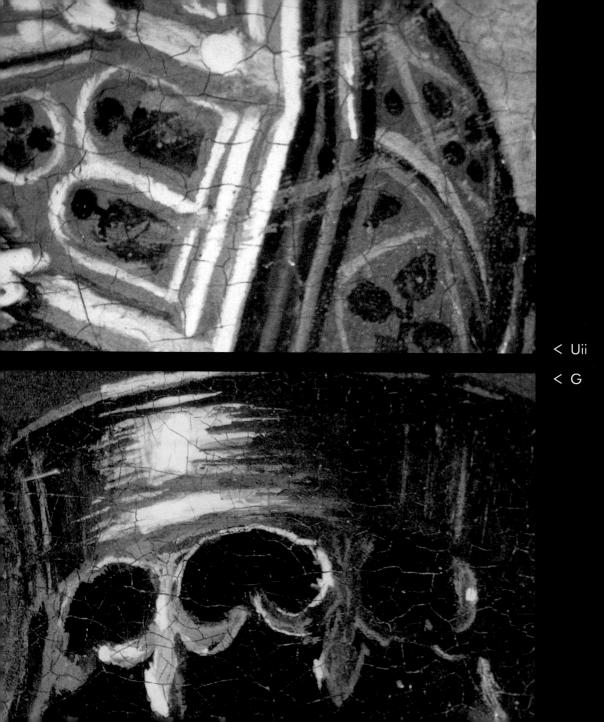

< Uii

< G

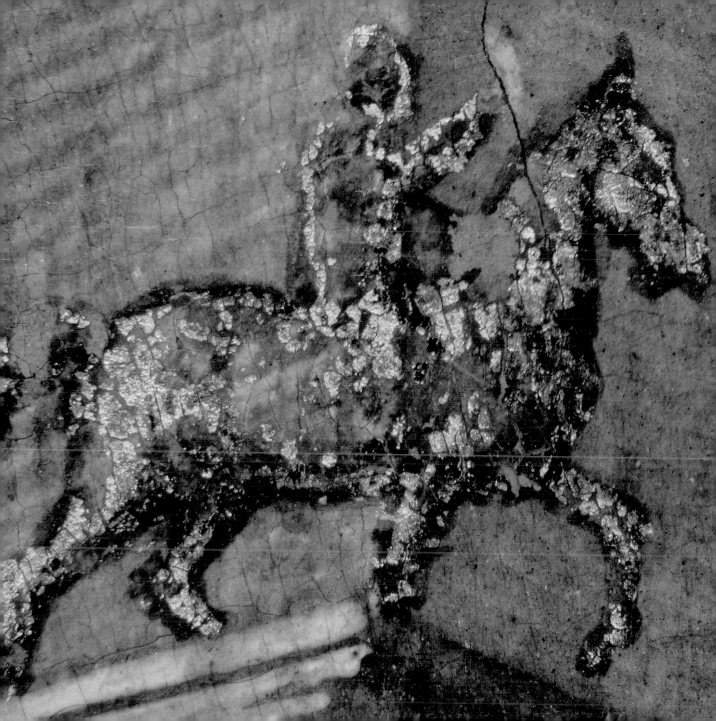

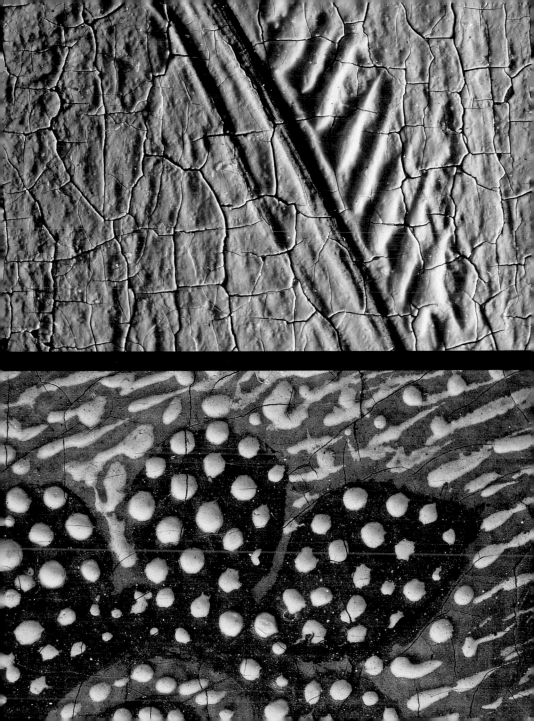

< Uii

< D

56

G >

Bii >

57

Fra Angelico (active 1417; died 1455)
*The Virgin Mary with the Apostles and
Other Saints: Inner Left Predella Panel,*
about 1423–4
Egg tempera on wood, 32 × 64 cm

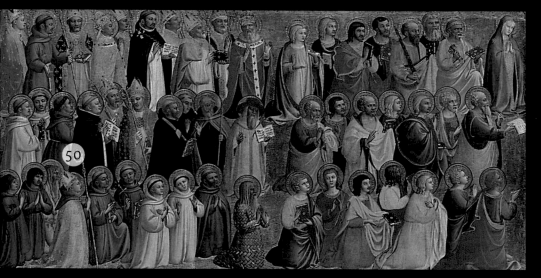

Guido di Pietro became a friar at S. Domenico, near Fiesole, before 1423, and took the name Fra Angelico. By 1441 he had moved into the Dominican friary of S. Marco in Florence, where he painted his greatest works in fresco as well as on panel, for the friars and their Medici sponsors. Summoned to Rome in 1445 by Pope Eugenius IV, he was active there and in Orvieto until 1449/50, when he returned to Florence. He died in Rome in 1455.

These two panels are part of the predella of an altarpiece painted by Fra Angelico for the high altar of S. Dominico, Fiesole, probably in the early 1420s. They are painted in egg tempera and reflect traditional Florentine painting practice for the first decades of the fifteenth century. The panels' meticulous execution, with gold and silver leaf and brilliant colours, are reminiscent of manuscript illuminations, which Fra Angelico may have made early in his career.

Fra Angelico (active 1417; died 1455)
Christ Glorified in the Court of Heaven:
Central Predella Panel, about 1423–4
Egg tempera on wood, 31.7 × 73 cm

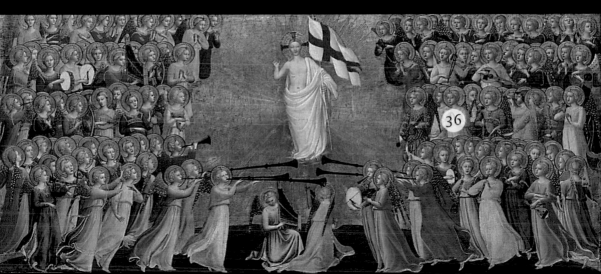

Antonello da Messina was born in Sicily but may have been trained in Naples. By the 1440s there were high-quality Netherlandish paintings in the city, as well as Netherlandish, French and Spanish painters who worked for the court, and it seems likely that he learnt to paint in oils there, rather than by making a special visit to the Netherlands as Vasari wrote in 1550. Antonello was also credited with introducing oil painting to Venice, but the oil medium had been used in Northern Italy for many years by the time he visited in 1475–6.

This panel may have been painted in Venice, and is known to have been there by 1529, when some connoisseurs of the time believed it to be by either Jan van Eyck or Hans Memling. Paintings such as this were greatly prized for their minute detail, and Antonello was able to satisfy a market among collectors for works painted in oil in the Netherlandish manner. While he was in Venice he also worked on a larger scale, painting an important altarpiece for the church of S. Cassiano.

Bii Antonello da Messina
(active 1456; died 1479)
Portrait of a Man, about 1475
Oil on poplar, 35.6 × 25.4 cm

C Francesco Bonsignori (1455/60?–1519?)
Portrait of an Elderly Man, 1487
Tempera on wood, 41.9 × 29.8 cm

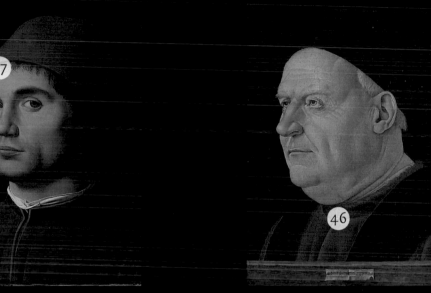

A surprising number of portraits by Antonello survive, all apparently painted in the 1470s, many of them in Venice. They are always of men and are mostly similar in size. The three-quarter view of the head and the lighting from the left shown here are part of a standard type, clearly based on Netherlandish examples. Within this formula, however, the different sitters have a strong individual presence, enhanced by the sense of volume that results from the artist's characteristic simplification of forms. Antonello exploited the potential of oil paint for rapid execution, which allowed h███ ██fil the many portrait commissions he received during his t███ █n Northern Italy.

Bonsignori was probably born in Verona, where he painted his first recorded work in 1483. While there he painted altarpieces and portraits, before moving to Mantua where he worked for the Gonzaga court from about 1490.

This portrait is signed and dated on a cartellino at the bottom. We do not know who is depicted, but the costume is thought to be that of a Venetian Senator. There is a drawing in the Albertina, Vienna, that is the same size and clearly associated with this painting, which Bonsignori may have used as a basis for this portrait. According to Vasari, however, Bons█████ often recorded his paintings with drawings, and so the drawing may █████ been made for this purpose.

We do not know when or where Bruegel was born, but in 1551–2 he became a master in the Antwerp Guild of Saint Luke (the painters' guild). In 1552/3 he journeyed in France, Switzerland, Austria and Italy, before returning to Antwerp to work mainly as a designer of prints. In about 1563 he settled in Brussels, where he died in 1569. His greatest paintings all date from the years 1559–68.

The vertical format and relatively rich colours of the *Adoration of the Kings* make it unusual among Bruegel's paintings. The format suggests that it was designed as an altarpiece, but its early history is not known. Bruegel's technique is at its most characteristic and skilful here. He usually applied paint very thinly and rapidly, but in places it is built up more thickly, or stippled on with stiff brushes. He preferred to paint wet-in-wet, sometimes scraping into paint while it was still soft to achieve a particular effect. In this painting he combines broad sweeping brushstrokes with passages of immense delicacy.

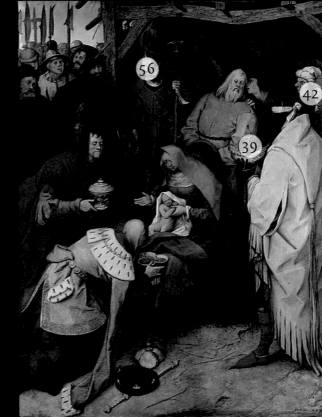

Ei Robert Campin (1378/9–1444)
A Woman, about 1435
Oil with egg tempera on oak, 40.6 × 28.1 cm

Eii Follower of Robert Campin
The Virgin and Child before a Firescreen, about 1440
Oil with egg tempera on oak with walnut additions, 63.4 × 48.5 cm

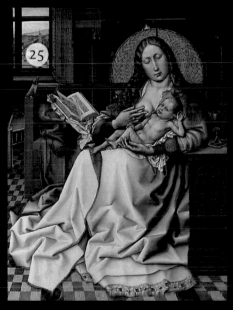

Campin was born in the late 1370s, and by 1405–6 was settled in Tournai, Flanders, where he pursued a successful and prosperous career. He ran a large workshop and appears to have been recognised in his lifetime as one of the most important painters of his generation. This painting shows his great skill and understanding of the properties of his materials. He used egg tempera, which dries quickly, for the underlayers and then exploited slower-drying oil paint to blend and feather brushstrokes, and to score lines into the wet paint to stress contours, which makes the folds of the veil seem strikingly three-dimensional.

The Virgin and Child before a Firescreen clearly shows the influence of Campin in its design, but not quite his level of skill in paint handling. In the nineteenth century a restorer added strips across the top and down the right-hand side, presumably to replace damaged areas. The Virgin is set in a realistic domestic interior, and the view out of the window to a busy town, complete with workmen and gossiping shoppers, is a fine example of the Netherlandish realism that later fascinated Italian collectors and artists such as Antonello.

Fi Lucas Cranach the Elder (1472–1553)
Portrait of Johann the Steadfast, 1509
Oil on wood, 41.3 × 31 cm

Fii Lucas Cranach the Elder (1472–1553)
Portrait of Johann Friedrich the Magnanimous, 1509
Oil on wood, 42 × 31.2 cm

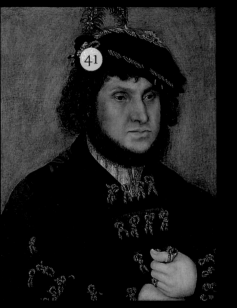

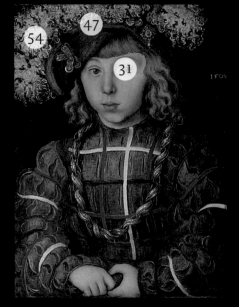

The artist's name comes from his birthplace, Kronach in Bavaria. He was probably taught by his father Hans and, from 1505, painted at the court of the Electors of Saxony at Wittenberg. These portraits, of Johann the Steadfast, the Elector of Saxony (1468–1532) and his son, Johann Friedrich the Magnanimous, who succeeded him as elector in 1532, were joined as a diptych. Both are in the original frames. Pairing portraits of father and son was unusual at the time, and may have come about because the six-year-old Johann Friedrich's mother, Sophia of Mecklenburg, died giving birth

to him. The paintings date from early in Cranach's career, and are fine examples of his wonderfully free, expressive style.

Cranach later went on to run a large workshop that produced a range of works including print designs, portraits, religious works and pictures of secular subjects. Possibly due to pressures of business, and the need to design compositions that could be reproduced by assistants, Cranach's work became more formulaic and careful, and seems to lack the freedom and liveliness of these early portraits.

Jan van Eyck (active 1422, died 1441)
Portrait of Giovanni(?) Arnolfini and his Wife ('The Arnolfini Portrait'), 1434
Oil on oak, 82.2 × 60 cm

Famed for his mastery of oil paint, Van Eyck painted devotional works, secular subjects and portraits. He worked for John of Bavaria in The Hague from 1422–4, and from 1425 found employment with Philip the Good, Duke of Burgundy, principally in Bruges. Among his most important works is the *Ghent Altarpiece* (in the Cathedral of St Bavo, Ghent), which was begun by his brother, Hubert van Eyck, and completed by Jan in 1432.

Vasari famously asserted that Jan van Eyck invented oil painting, but the medium had been in use for several centuries. However, he was certainly a remarkably skilled artist whose intimate understanding of the properties of different pigments in oil enabled him to achieve extraordinary results.

The Arnolfini Portrait probably shows Giovanni di Nicolao Arnolfini, a prosperous Italian resident of Bruges, with his second wife. They are depicted in a scene full of unexpected detail such as the cherries on the tree outside, the reflection of the orange in the polished wood of the window frame and the mud on Arnolfini's pattens. It is perhaps this degree of fine detail that makes this image so compelling and has encouraged viewers down the centuries to believe that this is a record, like a photograph, of a single instant – and that, as he wrote so prominently on the wall above the mirror 'Jan van Eyck has been here'.

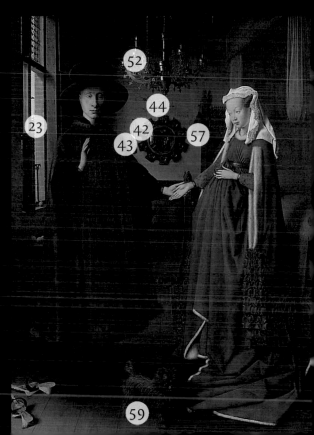

Garofalo (about 1476–1559)
Saint Augustine with the Holy Family and Saint Catherine of Alexandria ('The Vision of Saint Augustine'), about 1520
Oil on wood, 64.5 × 81.9 cm

Stephan Lochner
(worked: 1442; died: 1451)
Saints Matthew, Catherine of Alexandria and John the Evangelist, about 1450
Oil on oak, 68.6 × 58.1 cm

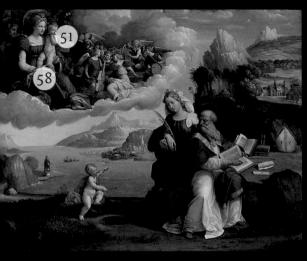

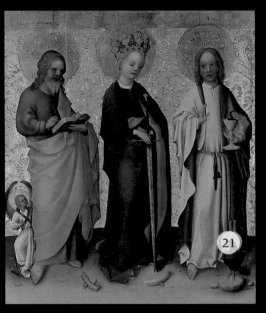

Benvenuto Tisi, known as Garofalo, was probably born in Ferrara, where was based for most of his life. He did visit Rome, however, where he saw the works of Raphael. A prolific painter of frescoes and religious subjects (both altarpieces and small devotional works), he also painted mythologies.

Garofalo's paintings are remarkable for their intense palette, and this small panel is a fine example of his distinctive use of colour. As well as the brilliance of the reds, oranges and ultramarine blues of the principal figures, he produced a wide range of subtly varied hues for the angels' draperies by mixing combinations of a limited number of pigments. The rich effect was then enhanced by adding touches of 'shell gold' along the borders of some of the draperies and the haloes of the saints and Virgin.

Stephan Lochner was the most important painter working in mid-fifteenth-century Cologne. It is thought that he made a number of altarpieces for Cologne churches, including the *Adoration of the Kings*, which Dürer may have seen in the Town Hall in 1520 (it is now in Cologne Cathedral).

This panel is the left wing of a small altarpiece and is painted on both sides. The paint on the reverse is damaged, but it once showed three standing saints and a kneeling donor. The right wing is still in Cologne and shows that this panel has been cut down, losing ornate gothic tracery at the top. The central part of the altarpiece has been lost, but may have been a piece of sculpture rather than a painted panel.

Ji Andrea Mantegna (about 1430/1–1506)
The Agony in the Garden, about 1460
Tempera on wood, 62.9 × 80 cm

Jii Andrea Mantegna (about 1430/1–1506)
The Virgin and Child with the Magdalen and Saint John the Baptist ('The Virgin and Child with Saints'), probably 1490–1505
Tempera on canvas, 139.1 × 116.8 cm

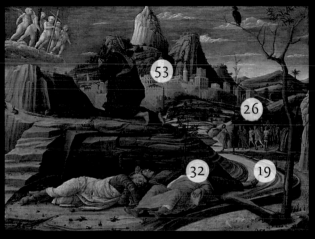

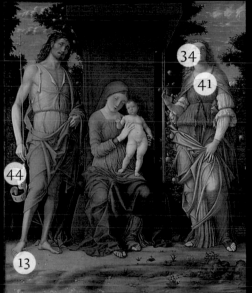

Mantegna was born in Padua, where he was apprenticed to Francesco Squarcione. He worked in Padua, Verona and Venice before moving permanently in 1459 to Mantua. There he became painter to the Gonzaga court.

Mantegna's *Agony in the Garden* is closely related to a predella panel, which shows the same subject, from his great altarpiece for the church of San Zeno in Verona. It may be connected with a drawing by Mantegna's father-in-law, Jacopo Bellini and Mantegna must also have known the studies of birds and animal by Pisanello, who was his predecessor at the Mantuan court. This painting is an example of Mantegna's absolute control of the tempera technique, which he uses to describe textures ranging from hard facet-ted rocks to soft rabbit fur.

This altarpiece, which Mantegna signed on Saint John's scroll ANDREAS MANTINIA C. P. F.[ECIT] (Count Palatine, or possibly Citizen of Padua, made it), is painted on canvas rather than panel. Mantegna often used canvas as a support for his work, including altarpieces, because, as he pointed out in a letter, 'it can be wrapped around a rod', making it more portable than a wooden panel. Mantegna's canvases were sometimes painted with pigments in glue size applied directly onto linen, but this one was prepared with gesso and painted in egg tempera, as a panel painting would have been. The texture of the canvas, with its diagonal twill weave, is apparent on the surface.

Imitator of Andrea Mantegna
The Maries at the Sepulchre,
perhaps 1460–1550
Oil on wood, 42.5 × 31.1 cm

K Marinus van Reymerswaele
(active 1535–1545)
Two Tax Gatherers, about 1540
Oil on oak, 92.1 × 74.3 cm

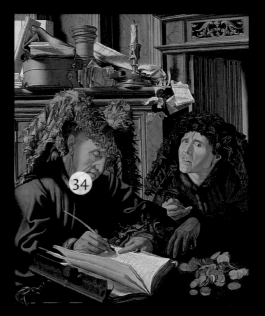

Mantegna was one of the most admired and influential
artists in Europe during the Renaissance. This panel,
which is one of a set of three in the National Gallery, was
probably painted in the early sixteenth century, possibly
not in Mantegna's lifetime. It is painted in oil and Mantegna
preferred tempera, using oil only occasionally for specific
effects. This panel may have been based on a lost painting,
or perhaps more likely, a lost drawing or engraving by
Mantegna himself. The extensive use of gold highlights
on some details suggests a possible connection with manu-
script illumination.

The 'Reymerswaele' of Marinus's name appears to refer to
Reimerswaal, a place once in Zeeland but now under the sea.
Many of his paintings include readable representations of
documents that contain references to the town and inhabit-
ants of Reymerswaele. All of the works signed by the artist
date from 1535–45.

Marinus seems to have specialised in a rather narrow
range of themes, and to have produced several exact, or
almost exact, re-workings of his few favoured subjects.
Recent research has shown that this painting was made by
tracing a nearly identical picture, also by Marinus, now in the
Musée du Louvre in Paris

L The Master of Moulins (Jean Hey)
(active 1483 or earlier–about 1500)
Charlemagne, and the Meeting of Saints Joachim and Anne at the Golden Gate, about 1500
Oil on oak, 72 × 59 cm

M Master of the Story of Griselda
(active about 1490–1500)
The Story of Patient Griselda (Part II), about 1493–5
Tempera and oil on wood, 61.6 × 154.3 cm

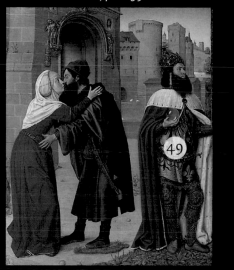

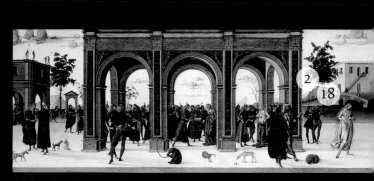

The artist of this panel is named after a triptych (made in about 1498) in Moulins Cathedral. It is now generally accepted that he was the painter Jean Hey. It is one of two surviving fragments from what was probably originally a rectangular altarpiece; it has been cut down the right-hand side and therefore must have been the left-hand part. The other fragment, which is cut on the left (now in the Art Institute of Chicago), depicts the Annunciation, but the subject of the central part ▮▮ known. Although painted in oil, and superficially similar to a Netherlandish painting, the way the paint layers have been built up and the handling of the paint confirm that the artist was not necessarily trained

This is the second in a series of three panels (all of which are in the National Gallery) that illustrate the Story of Patient Griselda, the last tale in Boccaccio's *Decameron*. All three were almost certainly commissioned for the double wedding of two brothers from a wealthy Sienese family, the Spannocchi in 1494. The anonymous artist, who is now known after these panels, seems to have had a very brief career and may have died young. He certainly worked in Siena, and may have come from there, but ▮▮ also shows the influence of Signorelli and other Umbrian painters – particularly in the way he uses oils. His few works show him to be painter of considerable decorative and narrative skills, full of wit and

Ni Hans Memling
(active 1465; died 1494)
A Young Man at Prayer, mid 1470s
Oil on oak, 39 × 25.4 cm

Nii Hans Memling (active 1465; died 1494)
*The Virgin and Child with Saints and
Donors (The Donne Triptych)*, about 1478
Oil on oak, 71 × 70.3 cm

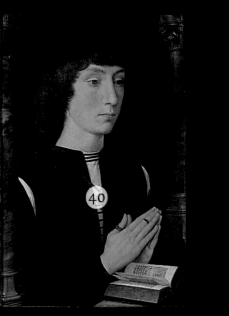

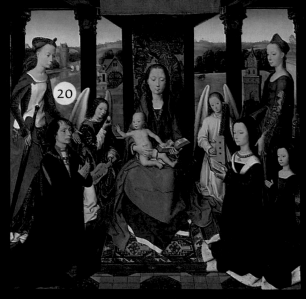

Profoundly influenced by Rogier van der Weyden, Memling
was the leading painter in Bruges from 1465–94 and ran a
large workshop to meet the demand for his paintings, which
he sent all over Europe. Memling was particularly popular
with Italian artists, judging by the number of them who
incorporated copies of his landscapes into their work.

A *Young Man at Prayer* was the left wing of a diptych (or
perhaps triptych) where the donor worshipped a religious
image. The relative simplicity of this composition allows
Memling to emphasise the various textures represented: the
hardness of the shiny marble columns and the pearls in the
jewelled cross contrast with the soft hair and velvet clothes.

The Virgin and Child with Saints and Donors is the centre panel
of an altarpiece commissioned from Memling by Sir John
Donne of Kidwelly, a very well-connected British patron. In
common with the pictures by Memling that were so popular
in Italy, the saints and donors are shown richly dressed in
carefully rendered velvets and ornately patterned cloth-of-
gold fabrics. They are placed before beautiful landscapes that
are full of incidental detail, such as a miller entering his mill,
swans on the river and men on horseback.

O Luís de Morales
(active 1546; died 1586?)
The Virgin and Child, probably 1565–70
Oil on oak, 28.5 × 19.6 cm

P Michael Pacher (active 1465?; died 1498)
The Virgin and Child Enthroned with Angels and Saints, about 1475
Oil on stone pine, 40.3 × 39.4 cm

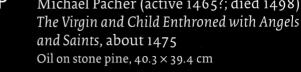

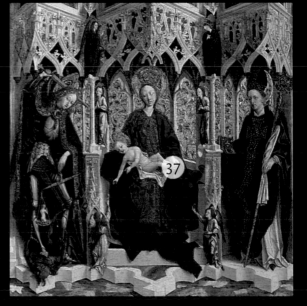

Morales was probably born in Badajoz, a Spanish town near the Portuguese border, where he lived for most of his life. Although he was very successful and was commissioned to paint large altarpieces for a number of churches, he seems to have specialised in smaller paintings of religious subjects, probably made for private devotion.

He was influenced by both Northern and Italian artists, and based compositions on works by Sebastiano del Piombo and Leonardo da Vinci. The delicate, soft sfumato effect in this *Virgin and Child* is clearly inspired by Leonardo, but the careful rendering of such details as the hair show a more Netherlandish influence.

Michael Pacher was a citizen of Bruneck (now called Brunico) in the Italian part of the Tyrol, where he ran a busy workshop. He was both a sculptor and a painter, and is now best known for his large altarpiece ensembles, which have sculpted wood at the centre and painted panels for the shutters.

This small panel is a miniature version of one of these, and its painted canopy and projecting platform are reminiscent of those in the sculpted centres of his larger altarpieces. Pacher has carved the relief decoration of the gilded background into the chalk ground, a technique seen on his larger works. The deep glazed tones of the draperies contribute further to the richness of effect.

Santi. He painted altarpieces for churches in Umbria and Tuscany before moving to Rome in 1508. In Rome he worked for two popes, Julius II and Leo X, and several important private patrons. He painted frescoes, portraits and altarpieces as well as designing tapestries and buildings.

The Mond Crucifixion is an early work that Raphael painted for the church of S. Domenico in Città di Castello, which is not far from Perugia. Although he may not have trained with Perugino, as has been thought, as a young man Raphael was almost certainly associated with his workshop. Perugino's influence on Raphael is srongest in the style and technique of this altarpiece: especially in the distant blue-tinged land-scape, the thin translucent flesh tones and the crosshatching of the glazes in the draperies. Even at this early stage in his career, Raphael had a complete mastery of the oil medium.

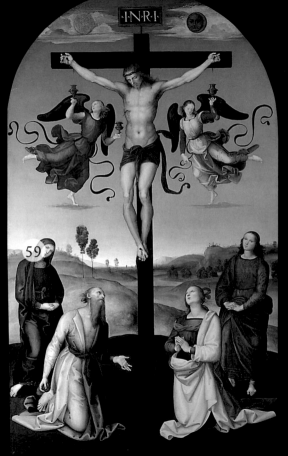

Qii Raphael (1483–1520)
The Madonna of the Pinks, about 1506–7
Oil on wood (possibly cherry), 29 × 23 cm

Qiii Raphael (1483–1520)
The Madonna and Child with the Infant Baptist (The Garvagh Madonna), probably 1509–10
Oil on wood, 38.7 × 32.7 cm

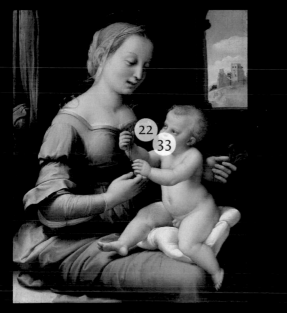

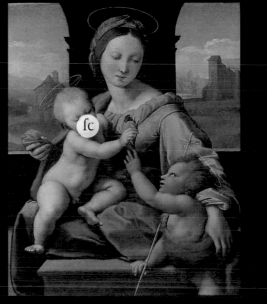

Raphael was in Florence by 1505, prompted by rumours about the painting and sculpture of artists such as Leonardo da Vinci and Michelangelo. The composition of the *Madonna of the Pinks* is based on Leonardo's *Benois Madonna* (State Hermitage Museum, St Petersburg). Its cool palette, lively interaction between the figures and drapery arrangement all reflect Leonardo's work, while the subtle description of light and shadow – and details such as the knotted curtain and the chip in the sill – reveal Raphael's familiarity with the works of Netherlandish painters. Not much larger than a book of hours, the painting may have been intended to be held in the hand for private prayer or contemplation.

The Garvagh Madonna is one of several Madonnas Raphael painted in the years following his move to Rome in 1508. Although not quite as small as the *Madonna of the Pinks*, the refinement of its technique has much in common with that work. There are also similarities between the drawn details and paint handling of the two paintings, for example in the eyes and mouths (see front cover), hands and feet. Unusually, Raphael executed the underdrawing of both panels in metalpoint. *The Garvagh Madonna* demonstrates Raphael's growing maturity as an artist, especially in the perfection of the underlying geometry of the design.

R Ercole de' Roberti
(active 1479; died 1496)
The Adoration of the Shepherds,
about 1490
Tempera on wood, 17.8 × 13.5 cm

Si Giorgio Schiavone (1436/7–1504)
The Pietà, probably 1456–61
Tempera on wood, 37.5 × 26 cm

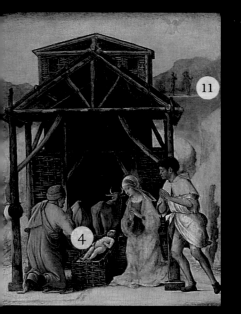

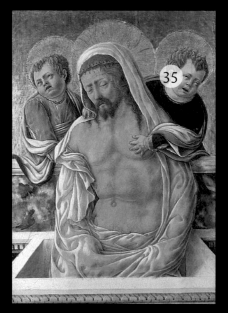

Ercole d'Antonio de' Roberti was active in Bologna, before moving to Ferrara in 1479. From 1486 he worked for the Este family, dukes of Ferrara. He was celebrated as a painter of murals, altarpieces and exquisite small-scale paintings. This panel is the left half of a tiny, hinged diptych painted for Eleonora of Aragon, who was the wife of Ercole I d'Este. The diptych was bound in rich purple velvet (fragments of the fabric survive on the reverse) as a luxurious illuminated manuscript might be. The minuteness of the tempera brushwork, which includes delicate touches of shell gold, emulates manuscript illuminations. The diptych would have been a precious object to be held during private devotions.

Juraj Culinovic was born in Dalmatia and was known in Italy as 'Schiavone', which means the Slav. He was apprenticed to Squarcione, the Paduan painter and sculptor, in about 1456–9, but left in 1462 and spent much of the rest of his life in Sebenico, Croatia. While in Padua he was a member of the circle of artists working under the influence of Donatello and the direction of Squarcione.

Donatello's influence is particularly evident in this *Pietà,* which was part of a ten-panel polyptych probably painted for the church of S. Niccolò in Padua. It was placed above the central panel of the *Virgin and Child* (illustrated right).

Sii
Giorgio Schiavone (1436/7–1504)
The Virgin and Child Enthroned,
probably about 1456–61
Tempera on wood, 91.5 × 35 cm

T
Antonio de Solario
(probably active 1502–1518)
The Virgin and Child with Saint John,
perhaps about 1500–10
Oil on canvas transferred from wood,
36.5 × 29.8 cm

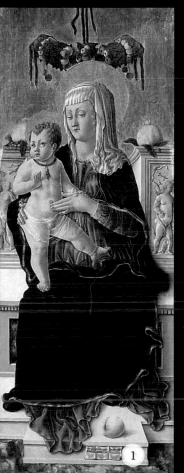

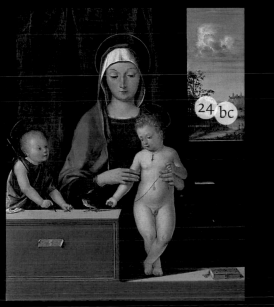

In addition to this centre panel and the *Pietà* (which was above it), Schiavone's altarpiece incorporated four full-length standing saints, two on each side of this painting, with another tier of four half-length saints above them. The tempera technique and way the figures are set against gold leaf backgrounds is traditional, but they have a solid three-dimensionality that is reminiscent of the sculpture Schiavone saw while he was in Padua. Details, such as the fly painted on the Virgin's throne, show the artist teasing the viewer with questions of reality. Other painters associated with Padua, notably Carlo Crivelli, also played with the contradictions inherent in painting illusions of space on the flat surface of a panel.

Antonio de Solario (Lo Zingaro) was probably trained, and perhaps born, in Venice. He is first documented in Fermo in 1502, and seems to have been active in the Marches for several years. He also appears to have worked in Naples painting frescoes, and may have visited England.

This picture reflects strongly the artist's Venetian training, not least in the richness of the colours, especially the abundance of ultramarine, and is probably an early work. The details in the landscape seen through the opening behind the figures, especially the tiny boats (see back cover) are reminiscent of similar boats in works by Netherlandish artists such as Van Eyck.

Ui

Rogier van der Weyden
(about 1399–1464)
The Magdalen Reading, before 1438
Oil on mahogany, transferred from another
panel, 62.2 × 54.4 cm

Uii

Rogier van der Weyden and Workshop
The Exhumation of Saint Hubert,
late 1430s
Oil with egg tempera on oak, 88.2 × 81.2 cm

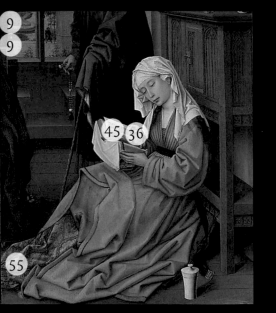

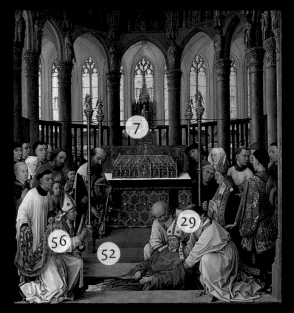

Van der Weyden was born in Tournai, and was probably the
Rogelet de le Pasture who is recorded as being apprenticed to
Robert Campin in 1427, and who became a master in the city
in 1432. By 1435 he was in Brussels heading a large workshop.

The Magdalen Reading is a fragment of a larger work:
the bottom right-hand corner of an altarpiece that has now
been lost apart from two fragments in Lisbon. The attention
paid to detail here is impressive given that the scale of the
finished work would have meant the detail could not have
been seen when the painting was on its altar. The skill with
which these details have been rendered is remarkable.

The Exhumation of Saint Hubert is part of an altarpiece made for
a chapel dedicated to the saint in the church of St Gudula in
Brussels. The altarpiece depicted scenes from Saint Hubert's
life, but only two panels are now known (the other panel is in
the Getty Museum in Los Angeles). Like the *Magdalen Reading*
this painting is full of amazing detail, and is painted for the
most part with great skill – but there are different approaches
to the painting of similar elements (for example the heads of
the protagonists and bystanders), which suggest that several
assistants were working on the panel as well as Van der
Weyden himself.

Uiii Workshop of Rogier van der Weyden
A Man Reading (Saint Ivo?), about 1450
Oil on oak, 45 × 35 cm

Uiv Workshop of Rogier van der Weyden
Portrait of a Lady, about 1460
Oil with egg tempera on oak, 37 × 27.1 cm

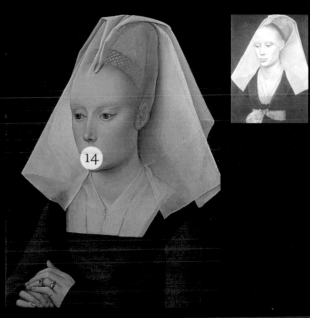

This small panel once bore an inscription which, although not original, identified the subject as Saint Ivo, patron saint of lawyers. This information could have been copied from a frame or another source, and it is possible that this work was meant to be seen with other pictures in a group. The style is similar to that of Rogier van der Weyden, but the artist was not quite as skilled a draughtsman or a painter as Rogier himself. Despite this, the picture is full of fascinating detail, especially the landscape seen through the window.

Van der Weyden painted a number of very fine portraits and his influence was wide reaching. Assistants in his workshop, as well as other artists, imitated the simple, uncluttered nature of many of his portraits, and their strong dependence on geometry and pattern. The *Portrait of a Lady* now in National Gallery of Art, Washington (right), is an example of Rogier at his best – the pattern of curves and straight lines makes a wonderfully controlled image and the skill of execution, especially when seen through the microscope, is remarkable. The London *Portrait of a Lady* is a good attempt to emulate this approach to portraiture, but it is ultimately less successful, both in its geometry and in the skill of painting.

V Marco Zoppo
(about 1432–about 1478)
The Dead Christ supported by Saints,
about 1465
Egg on wood, 26.4 × 21 cm

Marco (di Antonio) di Ruggero, Lo Zoppo, signed himself
Bononensis ('from Bologna'), although he was born in nearby
Cento. Like Schiavone he was apprenticed to Squarcione in
Padua and, in common with many other painters trained
there, he was also much influenced by the sculpture of
Donatello. Zoppo moved to Venice in 1455 and travelled
to Bologna in 1461–2. Some time after this he returned to
Venice, where he died.

　　Zoppo painted altarpieces and small works for private
devotion, such as this panel. The reverse is painted to repre-
sent marble, which indicates that it was a portable devotional
work. The panel's refined tempera technique is similar to that
of Mantegna, whom Zoppo would have encountered during
his time in Padua.

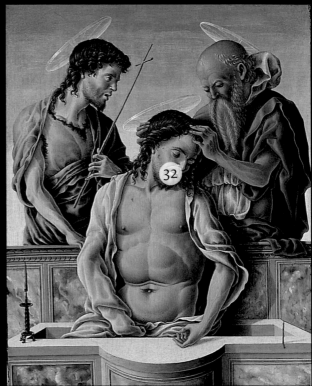